**basic
darkroom**

**by kirk
kirkpatrick**

PETERSEN'S PHOTO PUBLISHING GROUP

PHOTO SPECIALTY PUBLICATIONS
Brent H. Salmon/Publisher
Paul R. Farber/Editorial Director
Mike Stensvold/Editor
Jim Creason/Art Director
Lynne Anderson/Managing Editor
Celeste Swayne-Courtney/Associate Art Director

PHOTOGRAPHIC MAGAZINE
Brent H. Salmon/Publisher
Paul R. Farber/Editor
Karen Sue Geller/Managing Editor
Jim Creason/Art Director
David Brooks/Feature Editor
Steven I. Rosenbaum/East Coast Editor
Joan Yarfitz/Associate Editor
Markene Kruse-Smith/Associate Editor
Natalie Carroll/Administrative Assistant
Kathy Philpott/Production Artist
Ben Helprin/Contributing Editor
Kalton C. Lahue/Contributing Editor
Steve Poster/Contributing Editor
Robert D. Routh/Contributing Editor
David Sutton/Contributing Editor
Parry C. Yob/Contributing Editor
M.A. Hadley/Far East Correspondent

PETERSEN PUBLISHING COMPANY
R. E. Petersen/Chairman of the Board
F. R. Waingrow/President
Robert E. Brown/Sr. V.P., Corporate Sales
Herb Metcalf/V.P., Circulation Marketing
Philip E. Trimbach/V.P., Finance
Al Isaacs/Director, Graphics
Bob D'Olivo/Director, Photography
Spencer Nilson/Director, Administrative Services
Larry Kent/Director, Corporate Merchandising
William Porter/Director, Circulation
Jack Thompson/Assistant Director, Circulation
James J. Krenek/Director, Purchasing
Thomas R. Beck/Director, Production
Alan C. Hahn/Director, Market Development
Maria Cox/Manager, Data Processing Services

Library of Congress Catalog Card Number/75-27124
ISBN/0-8227-0121-9

COVER
Photo by David Brooks;
design by Jim Creason.
Inside front and back cover
photos by Leonard Nimoy.

introduction

There are two ways you can use this book. First, and simplest, you can skip this whole chapter on the theory of exposure and development, and start reading the next chapter on developing film. If you choose this option, you will be able to develop film and make prints by the time you've finished the book, but you won't know why you're doing what you're doing, if anyone should ask.

Your second option, and probably the better, is to read the rest of this chapter, which is a simplified explanation of how film and chemicals work. Should you choose this second option, you'll know why you're doing what you're doing in the darkroom, and can amaze and impress your friends.

SIMPLIFIED EXPLANATION

Photographic film consists of a thin, clear supporting base, over which an even thinner layer of an emulsion containing a silver halide and gelatin has been spread.

Now, a silver halide is a binary chemical salt, just as sodium chloride—common table salt—is. Silver halides consist of a metal (silver) and a halogen (bromine, chlorine, iodine or fluorine). Table salt consists of a metal (sodium) and a halogen (chlorine). This in itself is merely an interesting tidbit of trivia, but what is of vital interest to us photographers is the fact that the silver halides (most commonly in the form of silver bromide, silver chloride and silver iodide) are sensitive to light.

If you were to take a roll of film out of its box, grab the end of it and pull it out of its cassette, it would

darken right before your eyes. If you were to take a sheet of photographic printing paper out of its box in normal lighting conditions, it too would darken as you watched it. What you'd be observing is the silver halide in the emulsion reacting to light. It is upon this reaction that photography is based.

When you "click" your camera shutter, you allow a *controlled* amount of light to reach your film. By using the camera body to prevent the whole roll of film from being exposed to light at one time, and using the camera lens to focus an image of a scene on the film, and using the camera shutter speed and lens aperture controls to control the amount of light that hits the film, you can produce an image on the film that closely approximates the original scene.

1. An exposed roll of film— if you can get that far, this book will take you the rest of the way—through the negative to the finished print.

O.K., you now have an image on your film. But you can't see it. (If you take the film out of the camera and look at it, all the parts of the film that weren't exposed when you took the picture will be exposed by the viewing light, and the whole roll will turn dark as you look at it.)

Actually, even if you could somehow view the exposed (in the camera) film under

some sort of light that wouldn't "fog" it, you still wouldn't be able to see the image, because it is invisible. We call this hidden image the *latent image,* from the Latin word for "hidden."

How do we know the latent image exists if we can't see it? By indirect scientific evidence: If we develop an unexposed roll of film, we wind up with a clear strip of film, but if we develop a roll of film that has been properly exposed in the camera, we wind up with a roll of film with images on it. We can't see the latent image, but it must be there.

Well, then, how do we make this latent image visible? Of course—we develop the film. Actually, "process" the film is a

2

2, 3. Look over the diagram on page 6 and its explanation, then compare this print of model Denise Milburn with the negative that produced it and see if it all starts making sense.

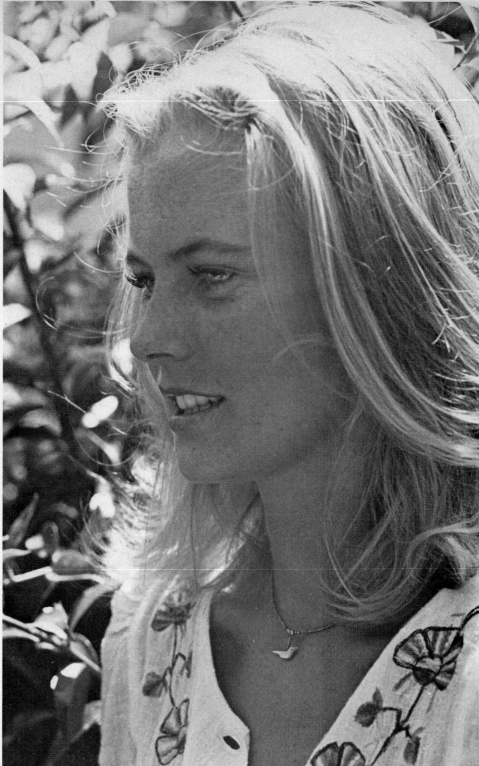

3

better term, for developing it is only one step in the process of producing usable visible images on the film.

The first processing chemical is the *developer*. This chemical amplifies the latent image by turning the light-struck silver halides into metallic silver. (Silver halides don't resemble metallic silver any more than table salt resembles metallic sodium.) Metallic silver is not sensitive to light.

If you could somehow view the film under some sort of light that wouldn't fog it after developing it (there is such a light, called a *safelight,* green in color), you could see the image on the film. But the portions of the emulsion that were not exposed (or were only partially exposed) in the camera are still sensitive to regular light, and will still turn dark before your eyes if you let regular light hit the film. So the next thing to do is render these parts of the emulsion insensitive to further exposure to light.

The chemical called *fixer* or "*hypo*" does this trick; it removes from the emulsion the silver halides that were not exposed to light by the camera (and therefore developed, or turned to metallic silver by the developer).

O.K., the developer made the latent image visible, and the fixer made the film insensitive to further exposure to light. Now you have a visible image that you can view under normal light. But you're not quite through yet. Some of the chemicals (developer and fixer) are still in the emulsion, and they must be removed by washing

the film in water. If the chemical residues are not removed by washing, they will continue to work, and will eventually attack the silver and stain the film.

Once the film has been

thoroughly washed in water, it should be hung up to dry. While the film is drying, let's consider some other chemicals that, while not essential, make processing film easier and/or "better."

A *stop bath,* also called *short-stop,* or even a brief rinse in water, can be used

between the developer and the fixer. The purpose of this is to bring a quick halt to the action of the developer, and to prolong the life of the fixer by keeping developer from being carried over into it. The stop bath does both more efficiently than the water rinse.

Another nonessential but very useful chemical is a *hypo eliminator,* or clearing agent. This is used after the fixer (hypo), before washing the film. As its name suggests, hypo eliminator removes hypo from the emulsion, thereby greatly reducing the time the emulsion must be washed to rid it of residual chemicals.

A third useful chemical is a *wetting agent,* which reduces the surface tension of water and therefore helps to prevent water spots on the film. The wetting agent is used after the washing of the film, just before hanging it up to dry. It causes the water to run off the emulsion smoothly, so that droplets don't cling to the surface and form water spots as they dry there.

After the film has dried, if you look at it you will see tiny images, reproductions of the scenes you photographed with the camera. But you will notice that the parts of the scene that were light appear dark on the processed film, and the parts of the scene that were dark appear light on the film. What you have on the film is negative images of the original scenes; we call these *negatives,* for short.

Why are the images on the film negative, instead of positive like the original scene? Well, bright areas in a scene reflect more light than dark areas, so the portions of the film on which the lens focuses these parts of the scene will receive

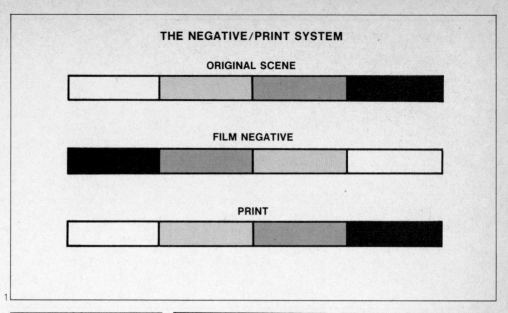

1. Here's how the negative/print system works. Imagine that we are photographing a scene consisting of four blocks: one white, one light gray, one dark gray and one black block. Normal scenes, of course, contain colored items, but these are reproduced as shades of gray in black-and-white photographs, depending upon how much light they reflect.

Our white block represents bright objects in a scene, those that reflect a great deal of light. That's why such objects appear white or light in tone—they reflect most of the light that falls upon them. Anyway, our white block reflects a lot of light, so the portion of the film upon which its image is focused by the camera lens will receive a lot of exposure. When the film is developed, this portion of the negative will appear black, since it was fully exposed. A lot of light = a lot of density (darkness) on the negative.

Our light gray block represents objects in a scene that reflect quite a bit of light, but not so much as white objects. The light gray block reflects quite a bit of light, so the portion of the film upon which it is focused by the camera lens will receive quite a bit of exposure, although not so much as from the white block. When the film is developed, the light gray block portion of the negative will appear dark gray. Quite a bit of light = quite a bit of density on the negative.

Our dark gray block represents objects in a scene

that reflect some light, but not very much. The dark gray block reflects only a little of the light, so the portion of the film upon which it is focused by the camera lens will receive little exposure. When the film is developed, the dark gray block portion of the negative will appear light gray. Little light = little density on the negative.

Our black block represents the darkest objects in the scene—black objects, deep shadows and the like. The black block reflects practically no light, so the portion of the film upon which it is focused by the camera lens will receive practically no exposure. When the film is developed, the black block portion of the negative will appear clear. No light = no density on the negative.

These same principles apply to tones in between those illustrated. The lighter the original subject, the darker it will appear on the negative, and vice versa. These principles assume that the film has been properly exposed. If a scene is grossly overexposed, all areas will appear black on the negative, and if the film is grossly underexposed, the whole negative will be clear.

That takes care of the original scene and the negative. Now for the print. When the negative is placed in an enlarger and its image is focused on a sheet of printing paper, the black areas (which represent the bright areas in the original scene) allow practically no light through to expose the paper. The portion of the paper upon which the black areas are focused therefore receives practically no exposure. When the paper is developed, this portion of the paper appears white—the same as the part of the original scene it represents.

The dark gray areas of the negative allow some light to hit the paper, but not much, so the portion of the paper upon which the dark gray areas of the negative are focused receives some, but not much, exposure. When the paper is developed, this portion of the paper appears light gray—the same as the part of the original scene it represents.

The light gray areas of the negative allow quite a bit of light to hit the paper, so the portion of the paper upon which these areas are focused receives quite a bit of exposure. When the paper is developed, this portion of the paper appears dark gray—the same as the part of the original scene it represents.

The clear areas of the negative allow nearly all the light to hit the paper, so the portion of the paper upon which these areas are focused receives a lot of exposure. When the paper is developed, this portion of the paper appears black—the same as the part of the original scene it represents.

Again, as with the negative, gross overexposure of the paper will result in a paper that is all black, and gross underexposure in a white paper.

To review: The more light that hits the emulsion, the darker (denser) the emulsion will appear on development. The less light that hits the emulsion, the lighter the emulsion will appear on development. Therefore, a negative of a scene appears "reversed"—the bright areas in the original scene appear dark, and vice versa—while a print made from the negative will appear like the original scene.

2

4

3

2. Film developer comes in cans and bottles, powder and liquid form. Liquids are easier to work with—you don't have to mix them from the powder. The 76 formula, available from several manufacturers, has been a standard for years.
3. Fixer ("hypo"), like developer, comes in both powder and liquid form, and liquid is the more convenient. Concentrate like this from Nacco (which contains hypo eliminator) is economical and time-saving.
4. Hardener should be added to fixer to harden film emulsion, make it less likely to be scratched during subsequent handling.

more exposure, and therefore turn darker, than the darker portions of the original scene, which reflect less light, and so produce less exposure on the film.

Well, all this is fine, but you want a picture that looks like the original scene, with light areas light and dark areas dark, right? Well, that's where the process of printing the negative comes in. You exposed the film in the camera, and processed it, and now you have a negative. Now, you will expose a sheet of printing paper to light shined through the negative, and process the sheet of printing paper in much the same way that you processed the film, and you will have a photographic print that looks like the original scene.

When you shine the light through the negative to expose the printing paper, the dark areas in the negative (which were the light areas in the scene) don't let much light through, and so these areas of the paper are not exposed very much, and therefore come out pretty light in the print—like the original scene. The light areas of the negative let a lot of light through to the printing paper, so these areas on the paper are exposed a lot, and therefore come out pretty dark in the print—like the original scene.

By using an *enlarger,* you can project the negative's image on a sheet of printing paper and make a print that is larger than the negative, which is kind of nice—much the same way as you project a color slide on a screen to see it big.

The exposed sheet of printing paper is processed in much the same way as the film was processed. A different type of developer is used, but it does the same thing to the paper emulsion that the film developer did to the film emulsion. Then a stop bath is used to stop the action of the developer, the same kind of fixer used for film is used to render the paper insensitive to light, the print is washed and dried, and there you have it—a nice picture of the scene you photographed.

One nice thing about printing is that paper is not sensitive to weak amber light. You can therefore perform the whole printing process under illumination from an amber safelight, so you can see what you're doing.

O.K., now that you know basically what happens when you expose film and paper, and what the processing chemicals are for, you're ready to learn just how to do all this neat stuff, and begin the long and happy hobby of doing your own photography from the click of the shutter to the finished print. □

1

3

2

1. Glacial acetic acid can be diluted 3:8 with water to make stock solution, which in turn can be diluted 1½ ounces to a quart of water to make economical stop bath. It's probably worth the extra money to buy ready-made stop bath, though.
2. Hypo eliminators permit washing times to be greatly reduced, saving water as well as time.
3. Printing papers come in many varieties. Those shown (Kodak, Ilford, Agfa and Du Pont) are all excellent.

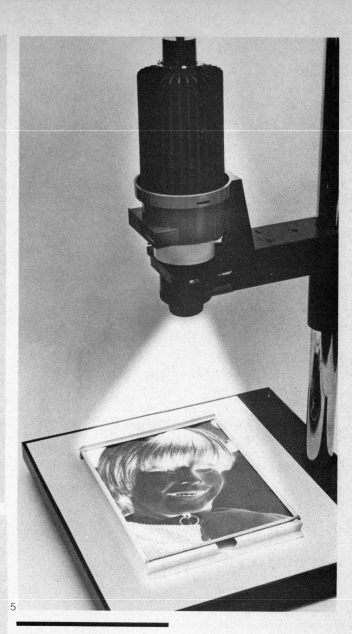

5

4. Paper developer is a bit different from film developer, but it does the same thing to the paper that the film developer does to the film: makes the latent image visible. Clayton P-20 is author's favorite.

5. Enlarger projects image of the negative onto easel containing printing paper just as a slide projector projects image of slide onto a viewing screen.

4

processing film

Processing film is really very simple and easy. However, you do need certain things before you can do it.

The first thing you need is the knowledge of how to process film. This chapter will give that to you. In addition, you need some chemicals, some equipment, and some dark.

You need the dark first, so we'll talk about it first. Since the film is sensitive to light until it has been treated with the fixer chemical, light must not be allowed to reach the film until then. Now, before you start worrying about how you are going to see what you're doing while processing the film in the dark, it should be pointed out that manufacturers make *daylight developing tanks,* which keep the film in the dark, but you in the light, as they allow you to pour chemicals in and out, but don't allow light to reach the film they contain.

So you really have to be in the dark only long enough to put the film into the developing tank. If you have (or have access to) a photographic darkroom, that is an ideal place to use to load the film into the developing tank. How dark is a darkroom? Well, the easiest way to check to see if your room is dark enough is to simply sit there and contemplate with your eyes wide open for about five minutes in the dark. If you can see your hand held in front of your face at the end of this time, your room is not dark enough.

If you don't have a photographic darkroom (or access to one), you might have a windowless room that can be darkened at night by

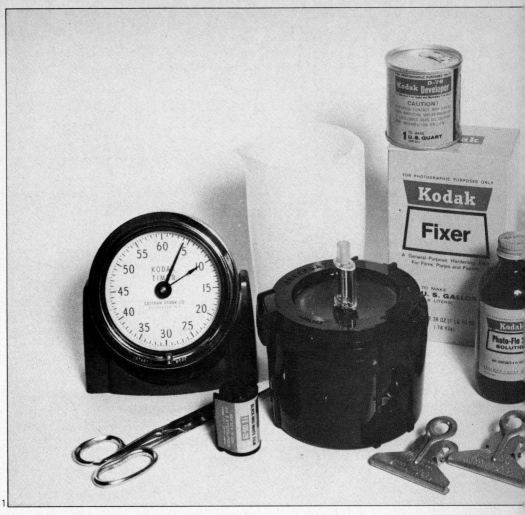

sealing doors so that no light can seep in, or a windowed room that can be darkened at night by sealing the windows as well. (Don't seal the room so that air cannot circulate, though!) You don't need water in the room, for the room will be used only for loading the film into the developing tank. Test the

sufficiency of the room's darkness as explained in the last paragraph, or to be really safe, try this:

Any doubts about how dark your room is can be dispelled for about a dollar. Buy a 20-exposure roll of 35mm black-and-white Tri-X

film. Unroll half of it in your darkened room and secure it so the emulsion side (side to which it curls) is facing up. Place a key or a coin on top of it, let it sit for about five minutes, then process the film. Lay your processed film on a white sheet of paper and check for a shadow. If you can see any trace or shadow of the key or coin on the film, the room is not dark enough.

luminous-dial watch if so equipped, and put your arms into the sleeves in the changing bag. Then, open the film cassette, roll the film onto the developing tank reel, put the reel in the tank, put the lid on the tank, pull your arms out of the bag's sleeves, unzip the bags, and you can remove your loaded developing tank and process the film in normal room light.

EQUIPMENT

O.K., now you've got the problem of dark handled. We'll next talk about the equipment you need. We've already mentioned the daylight developing tank. Several types are available. The stainless steel tanks will last a long time. They come with stainless steel reels that require quite a bit of practice to learn to load, but are nearly foolproof once sufficient practice has been put in. The plastic tanks will also last a long time, and their various plastic reels are easier to load—except when they're wet (the Vivitar tank's reels are an exception). Take an old roll of film with you (or buy a cheap outdated roll) and go to your local camera shop and try loading several different reels; the results will help you decide which is best for you.

Once you get your new developing tank home, use your practice film roll to practice loading with. Practice first by watching what you are doing, so that you get a good idea of exactly how the film goes onto the reel. Then, when you get good at that, practice loading the reel with your eyes closed. When you get good at that, try it a few times in your changing bag, if you are going to use one. Then, and only then, are you ready to put a real exposed

In the event that you can't make a room dark enough, you can buy an inexpensive *changing bag.* This resembles a black, rubber-lined shirt with no hole for the neck. It has two arms, into which you insert your arms. It is really two bags in one, an inner bag and an outer one, with zippers on each bag to keep the light out. The arms have elastic around the ends to keep light out.

To use the changing bag, unzip both bags, and place in the inner bag the things you'll need: the exposed roll of film, the developing tank, a can opener to open the film cassette (if you use 35mm film), and perhaps a pair of scissors. Then zip up both bags, remove your

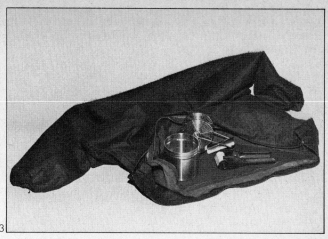

1. These are the basic things you'll need to process film: timer, measuring graduates, developer, fixer, wetting agent, thermometer, daylight developing tank, film clips, scissors, and roll of film.
2. To check on whether your darkroom is dark enough, un-roll half a roll of Tri-X film and secure it so that emulsion side faces up. (Do this with lights out.) Put a key on the film and leave it for about five minutes, then process film (or have it processed if you haven't read this chapter yet). Lay processed film on white sheet of paper and look for any trace of image of key. If there is a trace, your room is not dark enough.
3. If your room isn't dark enough, buy a changing bag. Put developing tank and reel (and lid!), film, cassette opener in bag, zip up, put arms in arm holes, and you have a portable darkroom.
4. A coat can be turned into an emergency changing bag if absolutely necessary. Be sure to fold it sufficiently to seal all light leaks.

roll of film into the tank.
If you work with 35mm film, you'll need some way of opening the film cassette. Some of the reloadable cassettes will pop open if you push down on the cassette against the long end of the spool, but most factory cassettes require an opener. A ''church-key'' type bottle opener is a very good one. Honeywell makes a nice cassette opener, and a pair of pliers will do in a pinch.

If you don't wind your 35mm film all the way back into the cassette when you've finished exposing the roll, but leave the tongue hanging out of the cassette, you can cut the tongue off before you go in the dark and open the cassette; otherwise, you'll have to cut it off in the dark. A pair of scissors works nicely for this purpose. You can, if no scissors are available, fold

the film and tear the tongue off, but scissors work better.

You'll need an accurate thermometer, because, as you will soon see, it is very important to have your chemicals at the right temperature if you want good results from your film processing. I prefer a good glass mercury thermometer because of its speed and accuracy, but since I am a klutz, I use the stem-and-dial type because I usually drop the glass ones or break them in the sink. Good thermometers such as Weston, Kodak, Beseler, Unitemp, Vivitar and Paterson are fine investments. The range of a darkroom thermometer is from about 60-120°F. Anything above or below this range is used so seldom as to be unimportant.

A timer is a worthwhile investment, although you can use any clock you might have around to time the processing steps. The timer should have a usable range of from one to 30 minutes, and it may have an alarm that sounds when the time is up, if you like that sort of thing. The Gra-Lab timer is a good choice, because you can use it for both film processing and enlarging.

Other equipment you'll need includes graduates (in photo stores) or measuring cups (in the supermarket). These will probably cost less at the supermarket, and an ounce is an ounce. . . . Two to four graduates in 32- or 64-ounce sizes are convenient.

You'll also need some containers in which to store your chemicals. Distilled water bottles make excellent chemical containers, and the distilled water is excellent for using to mix the chemicals. Never use household bleach bottles, and never use a container that has contained fixer to store developer in. No matter how carefully a

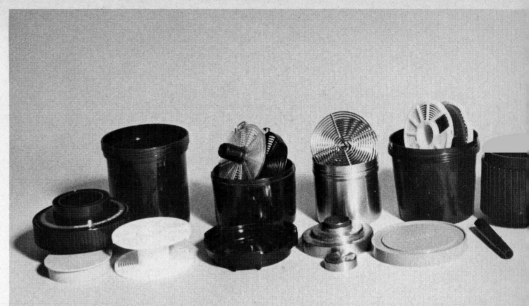

1

container may be washed, some chemical residue might remain to contaminate the next chemical you pour in. It's no longer necessary to use glass bottles for storage, nor is it necessary to use dark bottles. If you stored your chemicals in the sun, this would be essential, but it's a good idea to store chemicals in a cool place anyway. Don't store the chemicals in a refrigerator, though, for some chemicals tend to crystallize or go out of solution when cooled to too low a temperature. Temperatures between 60 and 80°F. are good storage temperatures.

A film washer is nice to have, and will save you a lot of wash water and time, by efficiently washing your film. One of the most efficient washers on the market today is the Wat-Air made by Pfefer Products. This washer introduces tiny air bubbles

into the flow of wash water to break the surface tension and quickly remove all remaining chemicals from your film. The shorter the time your film is allowed to remain in a wet state, the better your resulting negatives will be. Tests have proven that this washer does a complete job in less than five minutes. Lacking a film washer, you can use a short length of tubing that attaches to your water faucet and inserts into the core of your film reel. This method, used by Paterson of England and others, allows the water to force its way from the bottom of the tank up over the sides of the tank. Without use of tiny air bubbles to break surface tension, this method takes longer.

After the film has been washed, a soft, rubber-bladed squeegee is recommended to wipe excess water off the film and prevent water spots. Chamois and sponges are not recommended for wiping film because of their tendency to pick up grit and

dust particles from the air.

If you have the bucks, a film-drying cabinet can be purchased, but the film will dry if you just hang it up using film clips or clothespins, if your budget doesn't allow the drying cabinet.

CHEMICALS

The last group of things you need to process film is the chemicals. These include developer, stop bath, fixer, hypo eliminator, wetting agent, and—water.

DEVELOPER—We're not going to recommend a specific developer for your film. The standard, normal developers recommended by the film manufacturers are for the most part very reliable under average conditions.

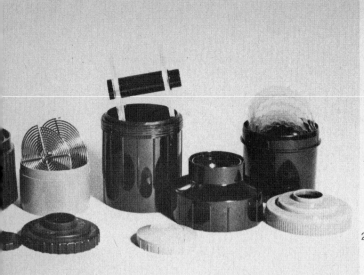

2

There are a lot of fancy developers that are available—compensating developers, two-bath developers, "push" developers—but these should not be used until you've mastered the standard developers recommended by the film manufacturers.

STOP BATH—You can buy ready-to-use stop bath at your local photo shop, or you can mix your own by adding 1½ ounces of 28-percent acetic acid to a quart of water. The acetic acid is also available at your photo shop. Mixing your own stop bath is more economical, but the ready-to-use stop bath made by Kodak is easier, and it turns color when it is exhausted (when it is time to mix up a new batch).

FIXER—In spite of the fact that there have been hundreds of developing formulas used since photography started, we still use essentially the same chemicals for fixing (removing the unexposed silver halides from) the film. First, and most commonly

1. A great variety of daylight developing tanks awaits you out there. Some good ones include Paterson, GAF, Nikor, Vivitar, Kindermann, Kodak. Take an old roll of film with you when you go tank shopping, and try loading several. Buy the one that you can load most easily.
2. Tongue must be cut off film before it can be loaded on developing tank reel. If you do this in roomlight, don't pull film out this far or you'll fog the first few pictures on the roll.
3. Devices to make loading steel reels easier are now available. This one is from Nikor. Loading reel must be done in dark!
4. Kindermann makes this gadget to simplify loading wire developing reel.
5. Paterson plastic reel is easy to load, uses ratchet mechanism to work film on.

3

4

5

used, is regular fixer containing sodium thiosulfate. This fixer ("hypo"—called that from its old and incorrect name "hyposulfite of soda") is most commonly used because of low cost.

A bit more expensive, the ammonium thiosulfate-based rapid fixer is a much more energetic chemical that fixes the film in about half the time a normal fixer requires. You must be careful not to use a rapid fixer for too long, or it will attack your silver image as well as the unexposed silver halides in the emulsion.

HYPO ELIMINATOR—As mentioned earlier, you can save a lot of time and water during the washing step if you use a hypo eliminator before washing the film. Kodak Hypo Clearing Agent, Heico, Perma-Wash, Beseler Ultra-Clear, Hustler and Orbit Bath are all good ones; just follow the manufacturer's directions as to their use.

WATER—Good old H_2O is a chemical. In most areas, tap water will be all right for processing, but certain impurities in local water supplies (notably calcium and magnesium salts in hard water) can adversely affect the developer. So it's not a bad idea to use distilled water to mix your developer with. Impurities in the water supply won't affect the other processing steps except that they might leave a scum on the film, so it is a good idea to follow the washing step with a rinse in distilled water.

While on the subject of mixing chemicals, we recommend that you use liquid concentrated chemicals rather than powdered chemicals whenever possible. With powders, you generally have to heat the water to a certain temperature, pour in all the powder, stir until completely dissolved, then

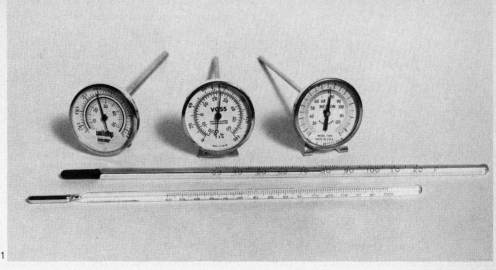

1

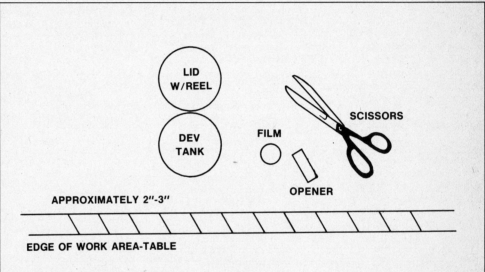

2

cool the solution to working temperature. With liquid concentrates, you just add the indicated amount of water and you're all set.

WETTING AGENT—Kodak Photo-Flo 200 Solution is an excellent wetting agent. It breaks surface tension of water, and allows the wash water to smoothly flow off the film when it is hung up

to dry, thus preventing water-spotting. Caution: Don't use too much Photo-Flo, or it will leave a residue on the film. A very little goes a long way—read the directions on the bottle.

REDUCERS AND INTENSIFIERS—In the event that you find some of your negatives too dark (dense) after processing them, you can use Kodak Farmer's Reducer to bleach them to a more usable density. This inexpensive chemical is used in normal light conditions—just follow the directions on the package.

If you find that through some catastrophe you have underdeveloped your film, you can use an intensifier such as Kodak Chromium Intensifier to bring up the density. Intensifiers will not work well if you have underexposed your film—the image has got to be on the film before you can work with it—but they will help if your film is underdeveloped.

Intensifiers and reducers should be used as emergency measures only—rarely is an intensified

3

4

5

1. Author prefers glass mercury thermometer, but uses stem-and-dial type for better durability.
2. If you always put things in the same place for reel loading, you'll always be able to find them. Here's a good arrangement.
3. Plastic bottles are good for storing chemicals. Use different colored bottles for developer and fixer, so you don't mix them up.
4. Wat-Air film washer from Pfefer Products is excellent washer that completely washes film in five minutes, saving both time and water.
5. Soft, rubber-bladed film squeegee is recommended to wipe excess water off film before drying, help prevent water Tpots.

or reduced negative as good or as easy to print as a properly exposed and developed negative.

PROCEDURE

Now that you have what you need, here's how to process your film.

First, always remember that cleanliness is vital to success. So are good work habits. Dirty darkroom equipment and careless techniques will show up in your final results, so right from the start practice care and cleanliness in your processing.

Make sure you have everything you need before you do anything else. Opening the film cassette in the changing bag and then discovering that you forgot to put the developing tank lid in the changing bag, or discovering with the developer in the tank that you have no fixer in the house can be traumatic experiences that are easily prevented by following the simple rule stated at the start of this paragraph. Make a checklist of what you need before starting, then follow it, each and every time. It is definitely worth the effort.

LOADING THE TANK—This was discussed earlier, but we'll review it here. You will need the film reel, the tank and its lid, the exposed roll of film, a cassette opener, a pair of scissors, and some dark (changing bag or darkroom).

The film generally will wind onto the reel in only one direction, so set the reel up properly before going dark. Remember to practice loading the tank (using an old roll of film) until you can do it properly without looking before you try loading a roll of film that matters.

Put everything you'll need where you can find it in the dark. This will save you time and frustration. Be consistent—if you always put each needed item in the same place, you'll always be able to find it.

A caution—don't get carried away with the scissors and cut your changing bag when you cut the film tongue off. This might be one good reason to leave the tongue hanging out of the cassette instead of winding the film all the way back into the cassette—so you can cut the tongue off in the light.

You will find that if you carefully wash your hands with soap and water and then thoroughly dry them before touching your film, it will make film handling much easier and safer—the natural oils on your hands could very easily leave fingerprints on your film. (Obviously, munching potato chips, peanuts and the like is a no-no in the darkroom.) If you get nervous and your hands start to perspire, stop and relax. Take your time. Don't rush. If there is a telephone around, take it off the hook, so it won't ring while you're in the middle of loading the tank.

Handle the film only by its edges. If you touch the picture area of the film, even with freshly washed hands, you'll probably put fingerprints on the emulsion.

PREPARING THE CHEMICALS

PREPARING THE CHEMICALS—Once the tank is loaded and capped, the film will be fine, so you can leave it, turn on the lights and get the chemicals ready to do their stuff.

Each chemical comes with directions as to how to mix it. Follow these directions to the letter. You'll need some developer (the one recommended by the film manufacturer is best to start with), some stop bath, some fixer, and some hypo eliminator. When you've had some experience, you can get by with two measuring graduates, using one for the developer only, and the other for the other chemicals, preparing each new one while the previous chemical is in the developing tank, but in the beginning, you should have a separate graduate for each chemical.

How much of each chemical should you prepare? Enough to fill your tank. It doesn't matter if you have only one roll of film in a two-roll tank; fill the tank or uneven development may result. This means 16 ounces in a tank that holds two 35mm rolls or one 120 roll. If you're not sure how much your tank holds, fill the empty tank with water, then pour the water into a measuring cup. That's how much of each chemical you should prepare.

Incidentally, if you should be developing only one roll of film in a two-roll tank, put the reel with the film on it at the bottom of the tank, then put an empty reel on top of that reel. Another tip—if you have several rolls to develop, and only one reel, be sure to dry the reel before reloading it with the next roll; it will load much more easily dry than wet.

When the chemicals have been mixed (label the measuring cups they're in,

1. The adage "Cleanliness is next to Godliness" might be trite, but it must have been meant for darkroom workers. The owner of these tanks most probably gets terrible results from his processing.
2. Most film and developer manufacturers provide time/temperature tables like this one from Kodak.
3. If your chemicals are too warm, you can put them in a refrigerator for a while, or put some ice cubes in plastic sandwich bag and put it into the chemicals. Don't put ice cubes directly into the chemicals, because they will dilute the solutions as they melt.
4. When all chemicals have been prepared, set timer, pour in developer, and start timer. With some tanks, it is better to tilt them a bit while pouring chemicals in— see tank's directions.
5. With this tank, agitation is done by means of a stirring rod.

	NEW DEVELOPING TIMES IN MINUTES									
KODAK Packaged Developers	SMALL TANK—Agitation at 30-Second Intervals					LARGE TANK—Agitation at 1-Minute Intervals				
	65 F 18 C	68 F 20 C	70 F 21 C	72 F 22 C	75 F 24 C	65 F 18 C	68 F 20 C	70 F 21 C	72 F 22 C	75 F 24 C
HC-110 (Dilution B)	6	5	4½	4	3½	6½	5½	5	4¾	4
POLYDOL	6½	5½	4¾	4¼	3¼	7½	6	5½	4¾	3¾
D-76	6½	5½	5	4¼	3¾	7½	6½	6	5½	4½
D-76 (1:1)	8	7	6½	6	5	10	9	8	7½	7
MICRODOL-X	8	7	6½	6	5½	10	9	8	7½	7
MICRODOL-X (1:3)	—	—	11	10	9½	—	—	14	13	11

Note: The development times have been changed as a result of a recent comprehensive study of all the factors affecting development.

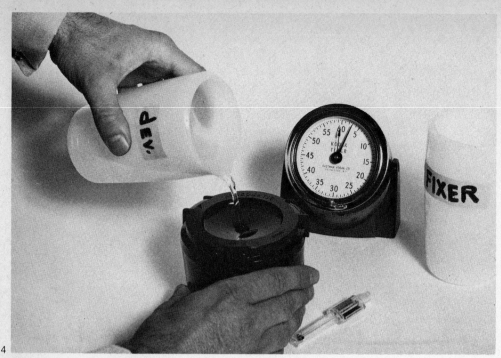

4

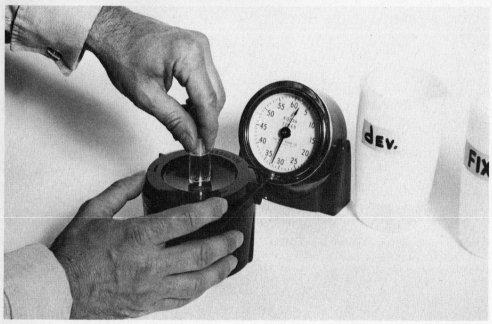

5

measuring cups containing them in a tray of hot water until they reach the proper temperature. If the chemicals are too hot, you can put them in the refrigerator for a while. Don't put ice cubes in to cool the chemicals, for they will dilute the solution as they melt.

If you have both hot and cold water available, you can adjust the temperature of the water before mixing the chemicals so that they will be at the proper temperature when mixed. If you use distilled water to mix your developer, this method won't work—you'll have to heat/cool the developer as discussed in the last paragraph.

Paying close attention to the time/temperature chart for the film/developer you're using (this chart is usually in both the film and developer directions) is important for your early work. When you have sufficient experience, you can "customize" your development to suit your needs, but for the time being, follow the manufacturer's directions to the letter.

While you are preparing the other chemicals, you should also bring a tankful of plain water to the proper temperature, to use as a prerinse. All chemicals should be at the same temperature (that of the developer), because variations in temperature from chemical to chemical can cause the film emulsion to shrink and swell, producing less than optimum image quality.

PROCESSING—Fill the tank with the water you prepared in the last paragraph, then pour the water out. This brings the tank up or down to the proper temperature, and helps to prevent air bells or bubbles from forming on the surface of the film when you pour the developer into the tank. These air bells are

so you don't get them mixed up—they all look pretty much the same), they should be brought to the proper temperature. The film's instructions usually contain information as to what temperature the chemicals should be, as well as how long to develop the film at a given temperature. Usually, 68°F. is the preferred temperature. Make sure the temperature you use is somewhere within the range listed on the developer instructions.

(It is important that the developer be at the proper temperature, and that the film be developed for the proper amount of time specified for that temperature by the film's instruction sheet, for the same reason that it is important that the film in the camera be exposed for the proper amount of time at the proper f-stop. Film can be over- or underdeveloped, just as it can be over- or underexposed, and the results are just as bad.)

If the chemicals are too cold, you can gently heat them in a pan (that you will never use for food) on the stove, or you can put the

a rather common problem and appear as small lighter areas on the finished negative. Since the first 30 seconds of developing time are the most critical, it is important that no bubbles of air form on your film to retard even the beginning of the development.

Set your timer for the time recommended in the time/temperature chart, or look at your clock if you don't have a timer, and pour in the developer. You'll find pouring chemicals into the tank goes most smoothly if you tilt the tank a little while pouring them in.

Agitate the tank as per directions. The film/developer directions will tell you how long and how often to agitate; the directions that come with the tank will tell you how to agitate the tank. Agitation is necessary to bring fresh developer into contact with the film—too little agitation will result in uneven development, but too much agitation will result in too-contrasty negatives. So follow the directions.

After the first agitation, gently tap the tank against a work surface to dislodge any air bells that may have formed on the film.

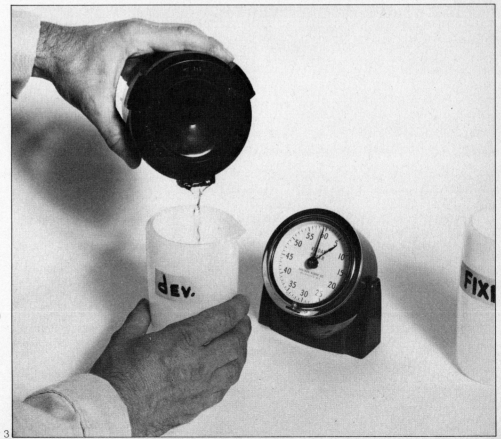

At the end of the development time, pour the developer down the drain or back into its measuring cup, and pour the stop bath or a water rinse into the tank. Agitate once, then pour out the stop bath/water rinse, and pour in the hypo, setting the timer or noting the time on your clock. Agitate the fixer the same way you agitated the developer.

(If you use a replenishable developer—one that you can use over and over by adding a little replenisher after each use—then add the replenisher and return it to its storage container after use. If you use a one-shot developer—one for which you dilute the stored solution

according to the film washer's directions. If you don't have a film washer, take the cover off the tank and let water run into the tank from a faucet. Wash for the amount of time recommended by the washer manufacturer or the film's processing directions, as applicable. Then give the film a quick rinse in distilled water to which a few drops of wetting agent have been added, to help guard against water spotting.

Hang the film up to dry. If you don't have a darkroom, a shower stall is a good place, because it is relatively dust-free. You can use film clips to hang the film from shower-curtain hooks, or install a piece of thick string and use clothespins to hang the film from it.

Use a soft, rubber-bladed squeegee to wipe excess water/wetting agent off the film, then put film clips or clothespins at the bottom of the hanging film strip to keep it from curling. A hint—dip the squeegee into the distilled water/wetting agent final rinse before using it on the film.

Do not stop to admire your negatives upon removing them from the wetting agent bath; squeegee them once from top to bottom and immediately hang them up for drying.

Several film drying cabinets are on the market, most of which provide a filtered warm air flow to facilitate quick, dust-free drying of your film, but in warm climates your film will dry very quickly in the air. Cold, damp climates in the winter time will of course make the use of a film drying cabinet more desirable.

When your film is thoroughly dry, you can cut it into convenient lengths for proofing (5-frame strips for 20-exposure 35mm rolls, 6-exposure strips for 36-exposure 35mm rolls, 4-exposure strips for 120 rolls). Don't try to cut the

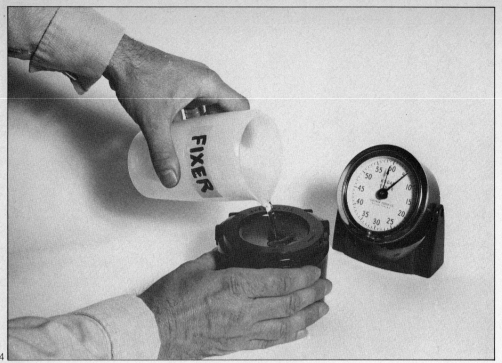

4

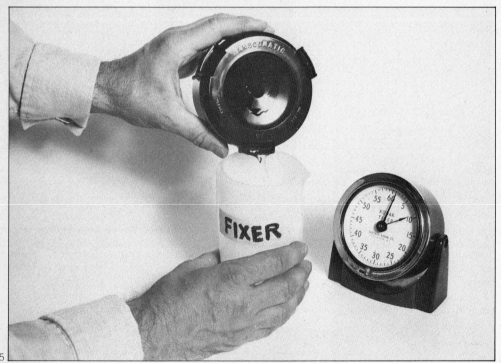

5

for use—throw it away after one use. The developer directions will tell you whether it can be replenished and how to replenish it.)

Fix the film for the amount of time recommended by the fixer manufacturer. If you use rapid fixer, don't exceed the time recommended by

1, 2. Metal tanks with caps are agitated by inversion.
3. After developing cycle is completed (when timer goes off), pour out developer. If you choose, you can now pour in a stop bath, or a plain water rinse, agitate once, then pour it out.
4. Pour in fixer, and start fixer timing cycle.
5. After fixing cycle is completed, pour out fixer. If you use hypo eliminator, pour it into the tank for the required time, then pour it out. Then wash the film.

the manufacturer. When the time is up, pour out the fixer (you can save and reuse it).

If you use a hypo eliminator, pour it into the tank, and use a time and agitation method recommended by its manufacturer. When the time is up, pour out the hypo eliminator.

If you have a film washer, put the reel containing the film into it, and proceed

film while it is still wet, or it will curl severely, making proofing difficult, and possibly damaging the film. Cutting any roll of film into single-exposure sections is not recommended because the short lengths are too hard to handle in making enlargements.

POST-PROCESSING—At this point, you may examine your negatives with a magnifying glass or a loupe to check your focus, composition and so forth.

You will find an excellent guide to your proper or improper development provided by film manufacturers in the form of the frame numbers printed on the edge of your film. These are exposed at the factory at the recommended ASA speed for each particular film. Thus if the numbers on your developed film are weak and light, you haven't developed your film as much as the manufacturer recommends. If the numbers are very dark and tend to bleed together, you have overdeveloped your film. For normally developed film at the recommended ASA speed, you should find the frame numbers crisp and black, very sharp, not gray.

One test for both exposure and development is a poor man's densitometer—the printed page. Lay your negatives on this page. The densest or darkest parts of your negative should allow you to just barely read this print through them. If your negatives pass this test, then you should be able to print them well.

To check your technique of juggling all the variables you are working with, try this simple test. Using a medium-speed film, take three pictures of a single "normal" daylight scene—a yard, street, or so forth—the first at normal recommended exposure, the second at double the normal ASA (in other words, one stop underexposed) and the third at one-fourth the normal ASA (i.e., two stops overexposed). Develop the film normally and examine these three negatives carefully. The densest part should not be too dark to read the print through nor should the thinnest part lack some detail.

Make an enlargement of each of these negatives and you will quickly see which will provide the best detail in both shadow area and highlight area. The underexposed negative should yield excellent highlight detail with little or no shadow detail. The overexposed negative should give you good shadow detail, but the highlights should be blanked out.

The normal exposure should give you both highlight detail and shadow detail. If this doesn't happen,

1

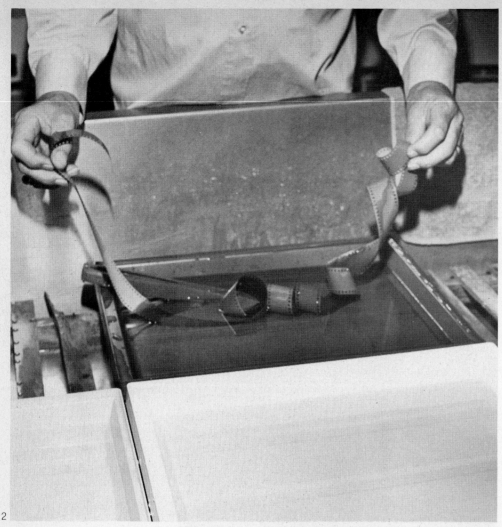

2

you must examine your variables. For example, camera shutter speeds are subject to mechanical variances, maybe as much as a half-stop off. Light meters are not all perfect either. Thermometers, too, are not all that reliable. Suppose your camera shutter speed is one-half stop slow, your light meter is one-half stop under, and your thermometer is two degrees under—you now have the equivalent of two f-stops' overexposure by relying on all these variables. This can be total disaster to the careful worker.

Many times these variables will cancel each other out, resulting in a perfect negative. If this is not the case, you must check each by comparison. Your local camera repairman can check your shutter speeds and calibrate your meter for you, thus assuring you of their accuracy. Thermometers will vary also, so always use the same thermometer when testing your chemical temperatures. This will at least assure you of consistency.

If you live in Phillips, Nebraska or Bodie, California, and have no local repair shop to calibrate your equipment, another way of compensating for or compromising to adjust to the variables would be to develop your film at two degrees more or less than your thermometer tells you. If your negatives are consistently too dark or dense, use the 66° marking on your thermometer as normal. Reversing the technique, use 70° as normal if your negatives are always thin.

Once you've established good developing procedures, you're ready for the next step on your journey to great photos. □

1. One way to apply wetting agent to film is to run roll of film through tray of wetting agent solution as shown (there will—or should— be images on actual processed film roll). Better way is to give film (still on reel in tank) quick rinse in distilled water to which a few drops of wetting agent have been added. This helps prevent water spotting.
2. Seesaw method of processing film is messy and inconvenient. Daylight developing tanks have all but eliminated it.
3. Squeegee film to remove excess water, then hang the roll up to dry.

3

proof sheets

Now that you have your film developed and dried, the next step is to check your results by means of a *proof sheet,* sometimes called a *contact sheet* because the negatives are placed in contact with the printing paper to make one.

The proof sheet has several uses. It can be used to compare your exposures (over-, under- and normal exposure) for reference when making your enlargements—you can see on the proof sheet that the frame you are about to print came out lighter than the one you just printed, so you should give it more exposure, etc. The proof sheet provides a good means of checking expressions in people pictures, something that is nearly impossible to do by looking at negatives. And it provides a handy filing device that lets you easily find a certain picture for later printing.

WHAT YOU NEED

All that you need to make a proof sheet is a pane of glass, a piece of cloth or thin sponge, a light source, some printing paper, some chemicals, and some dark.

GLASS—The purpose of the pane of glass is to hold the negatives in flat contact with the printing paper during exposure. If the negatives are not held flat, the images on the proof sheet will not be sharp.

Any sheet of glass will do, as long as it is devoid of scratches, imperfections and fingerprints. It is a good idea to get a pane of glass from a glass supplier, cut to a size large enough to cover the

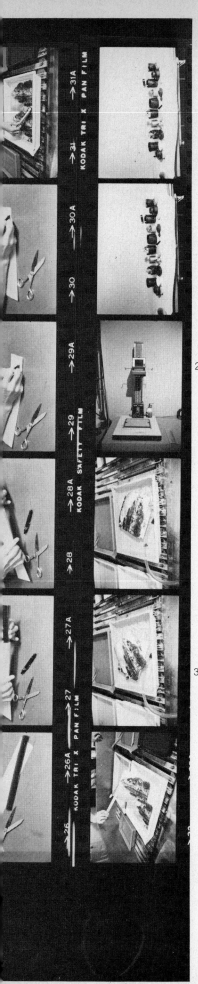

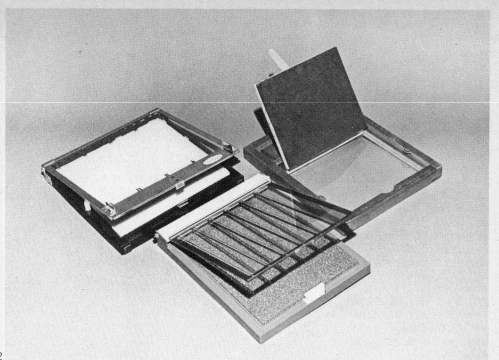

2

3

1. Proof or contact sheet is sheet of paper upon which an entire roll of film has been printed. Proof sheet is an economical method of checking which negatives you'd like to enlarge.
2. Proof printing frames make proof printing easier, but are not absolute necessities.
3. Film should be cut into strips of appropriate length for proofing, whether or not a proofing frame is used.

largest size proof sheet you'll want to make, with the edges finished so you won't cut yourself. If you choose to use a piece of scrap glass, tape the edges to prevent cuts. Be sure to clean the glass before use—any marks on it will be reproduced on your proof sheet—and wipe away all cleaning fluid before placing the glass upon your negatives.

Several manufacturers, such as Premier, Paterson and Technal, make special printing frames or proof printers that offer the advantages of easy reprintability if you miss your proper exposure time on the first try, and a much neater, more legible proof sheet, and easier handling of curly negatives.

CLOTH OR SPONGE—The purpose of this is to provide support for your proof sheet

sandwich, if you go the glass route rather than use a printing frame.

LIGHT SOURCE—This can be the overhead room light, your enlarger, or a bare light bulb suspended over your proofing area.

PAPER—For those who need only a temporary quick look at their proofs, the use of *studio proof* paper is recommended. Also known as *sun proof* or *printing-out* paper, this paper requires no darkroom and no chemical development, relying instead on the sun as a light source to provide a temporary image on the paper. This image is usually a reddish-brown color and is not permanent. The paper may be handled in normal room light quite safely. Its image will later turn entirely dark, destroying its future usefulness, so it is recommended only for those who need only a quick temporary look at their proofs.

For a permanent proof, photographic contact or enlarging paper must be used. These both must be handled in the darkroom under a red or amber-colored safelight or no light at all, and they must be processed in normal photo chemicals. Enlarging

paper is much more sensitive to white light than contact paper, but you may use it for proof sheets, the advantage being you won't have to buy a special paper for proofs only.

Whatever paper you use for making proof sheets, it should have a glossy, untextured finish—any texture in the paper finish will hide detail in the tiny pictures on the proof sheet.

CHEMICALS—The same stop bath, fixer and hypo eliminator used for film work just fine with photo paper, but a paper developer should be used, rather than a film developer. Several manufacturers make paper developers. My favorite is Clayton P-20, but if you can't find it, try the developer recommended by the directions that come with your paper.

DARK—It would be a little difficult (a lot, actually) to make proof sheets in a changing bag. For this, you are going to need a dark room. The room doesn't have to be totally dark. For one thing, you can use a red or amber safelight (available at your local photo store), so you can see what you're doing. For another thing, paper isn't nearly as sensitive to light as film. You can use the same test as explained in the film processing chapter to see if your room is dark enough—just take out a sheet of printing paper in the darkened room, put a coin or key on it, and leave it for

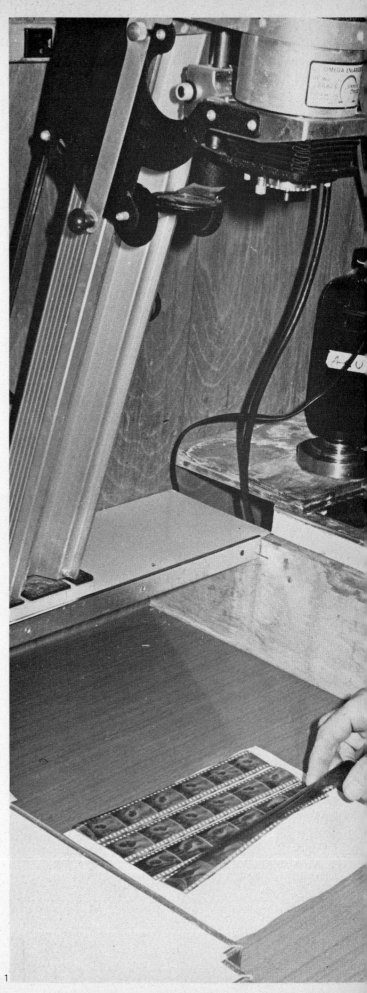

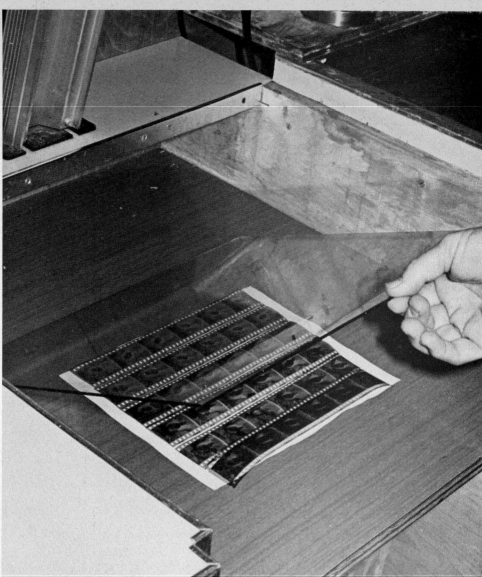

1, 2. One alternative to frame
is to put sheet of
printing paper emulsion side
up on enlarger baseboard (or
under light bulb if you don't
have an enlarger), position
negatives emulsion side down
on paper (under safelight
illumination), then cover
with sheet of clean glass.
3. Another alternative
is this "sandwich,
consisting of cloth or sponge
support, printing paper,
negatives and sheet of glass.
Light source can be enlarger
if you have one; otherwise a
plain light bulb will do.

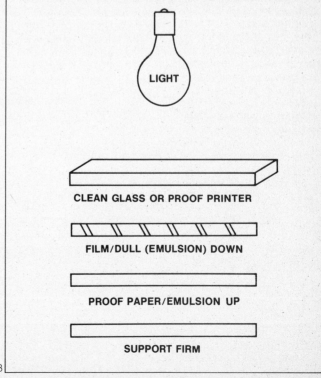

LIGHT

CLEAN GLASS OR PROOF PRINTER

FILM/DULL (EMULSION) DOWN

PROOF PAPER/EMULSION UP

SUPPORT FIRM

five minutes (with the safelight on, if you have one). Then, process the paper, and if you don't see any trace of the coin/key, your room is dark enough. If you do see a trace, you'll have to make the room more light-tight, by using additional layers of material to cover windows and to seal doorways.

PROCEDURE

First, prepare the chemicals, following the directions that accompany them. The chemicals, once mixed and at the proper temperature—68°F.— should be put into trays large enough to hold the printing paper you'll be using. These plastic trays are available at photo stores. The preparation of the chemicals can be done anywhere that water is available, but the trays must be placed somewhere in the darkroom.

You'll find that you can proof an entire roll of film (20- or 36-exposure 35mm film, or a 120 roll) on one sheet of 8x10-inch printing paper if the film has been cut into strips as explained in the film processing chapter—cut a 20-exposure 35mm roll into four strips of five frames each, a 36-exposure roll into six strips of six exposures each, and a 12-exposure 120 roll into three strips of four exposures each.

With this in mind, and in the dark, chemicals in their respective trays (developer, stop bath, fixer, and hypo eliminator if desired), you're ready to go.

Assuming you are using the pane-of-glass method rather than a printing frame, this is the procedure:

1—Place your negatives on the clean glass with the emulsion (dull) side up. Try

to line the negatives up with each other fairly evenly, to produce a neat proof sheet.

2—Take out a sheet of printing paper and place it, emulsion-side down, on top of the negatives. The emulsion side of the paper is the shiny side, unlike film. The light from the safelight should make it easy to see what you're doing.

3—Place a supporting piece of foam rubber or soft cloth on top of the paper, then place a firm piece of wood or plastic on top of the rubber or cloth.

4—Turn this unit over. You now have a sandwich in the following sequence: glass, negatives, paper, support. This sandwich is placed, glass side up, under a 25-watt light bulb that is approximately three feet above it.

5—Make an exposure with the light by turning it on for

about three seconds.

6—Remove the sheet of paper from the sandwich, taking care not to damage the negatives in the process. Place the paper face up in the developer tray, and gently rock the tray to agitate the print constantly for 1½ minutes. By the end of this time, most of the images on the proof sheet should be clearly visible.

7—After the 1½ minutes in the developer (with continuous agitation by gently rocking the tray), take the print out of the developer tray and place it in the stop bath tray for about 10 seconds, with continuous agitation.

8—Take the print out of the stop bath tray and place it in the fixer tray. It is a good idea to hold the print over each tray and let the excess solution drip back into the tray before transferring the print to each new tray of chemicals.

After about 30 seconds of agitation in the fixer tray, you can turn on the room light and examine your proof sheet. Continue to fix the print for the required time (see the directions that accompany the fixer), but you can look at it in the tray.

A good proof sheet should have the majority of your pictures plainly visible for

1. If some of your negatives are denser (darker) than others, you can cover the less dense ones with pieces of cardboard and give the denser ones additional exposure to produce a more balanced proof sheet.
2. Exposed proof sheet is placed in developer tray face up and is developed for 1½ minutes with continuous agitation. Make sure whole sheet is covered by developer.
3. After about 30 seconds in fixer tray with constant agitation, proof sheet can be examined under normal light.

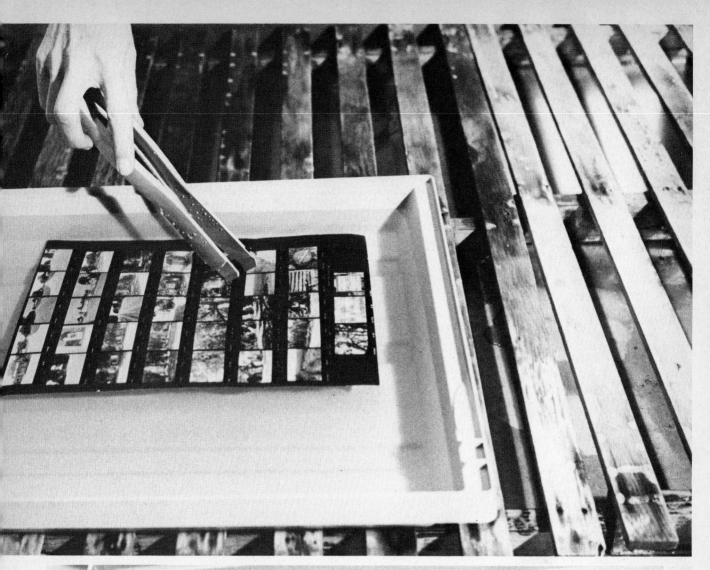

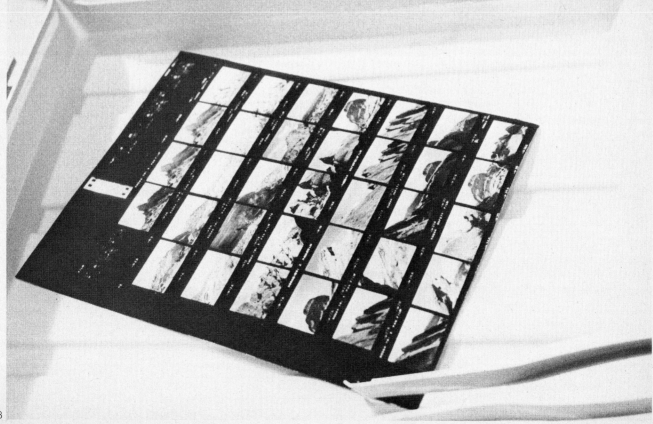

evaluation. If most of the pictures appear too dark, you must repeat the operation, but using less light. If most of the pictures are too light to evaluate, more light is needed.

(Printing paper, like film, comes in various "speeds"—sensitivities to light. There are fast and slow papers, just as there are fast and slow films. Other factors that affect the exposure of the proof print are the density of your negatives; the intensity of your light source; the f-stop the lens is set at, if you use an enlarger as the source; and the time of exposure. The three seconds of exposure with a 25-watt light bulb three feet from the paper is a pretty good starting point, but may not be just right if your paper is faster or slower than mine.)

If the proof sheet is too light overall, it requires more exposure. This can be accomplished by keeping the exposing light on for a longer time, or by moving the exposing light closer to the paper. If the proof sheet is too dark overall, it needs less exposure. This can be achieved by turning the exposing light off sooner, or by moving the exposing light farther from the paper.

Sometimes, if some of your pictures are improperly exposed, you will find some pictures on the proof sheet too light or too dark, while the rest are perfect. If this happens, you can make two proof sheets, one that reproduces the properly exposed pictures properly, and one that reproduces the other pictures in usable fashion (use the same rules just mentioned—if they're too dark on the proof sheet, give

1

less exposure; if they're too light, give more exposure).

An alternative method of balancing your proof sheet involves moving the light farther from the paper, to extend the exposure time to about 10 seconds. This longer exposure time would allow you to cover with pieces of cardboard those negatives that receive too much light and turn too dark when developed. These less dense negatives would be covered for part of the exposure time, while the denser negatives would receive the full exposure. Determining just how much less exposure the thinner (less dense) negatives require than the denser ones is a matter of trial and error, but as you gain experience in this exercise, you'll be able to guess pretty well what exposure to use for each of them.

After the proof sheet has been in the fixer (with agitation) for the recommended time, it should be washed to ensure permanence. Washing time in running water should be a minimum of 30 minutes to be sure most of the fixer is removed. Paper must be washed longer than film because the paper base absorbs more chemicals

than does the film base.

A more efficient washing is achieved by first using a hypo eliminator such as Kodak Hypo Clearing Agent, Orbit Bath, Hustler, Perma-Wash, Beseler, etc. Fixer does not dissolve readily in cold water, and hypo eliminator makes it dissolve more readily. If the fixer is not completely removed, the print will later stain, fade and/or turn yellow as the chemicals left in the print continue to work. Your prints represent too much investment in time, effort and money to risk ignoring this most important washing step.

After properly washing your proof sheet(s), the next step is drying. I personally do not like blotter books for drying prints simply because they do not allow proper air circulation. Blotter rolls are a better choice for an inexpensive way to dry prints. Electric print dryers are available from about $15

2

on up the scale according to size and convenience. If only a few proofs are made, the wet prints may be placed between two dry cloth towels and allowed to remain overnight.

The dried proof sheets can be marked on the back with such information as subject, date, film type, film

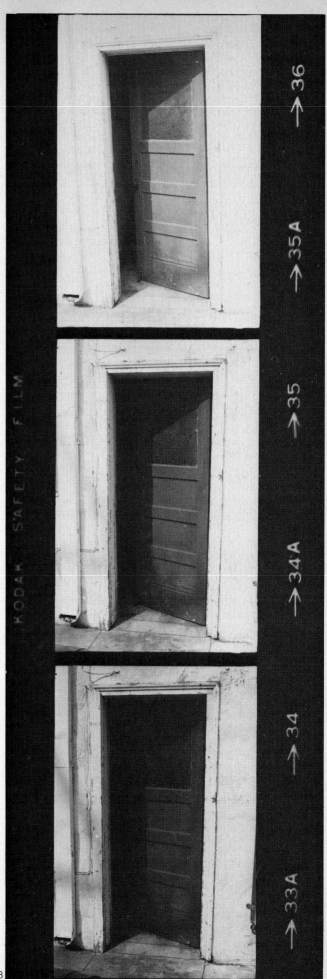

KODAK SAFETY FILM

→ 36
→ 35A
→ 35
→ 34A
→ 34
→ 33A

1. Economical way to dry proof sheet is to set it on towel, then fold towel over it.
2. Information such as film type, subject, date, processing data, location, etc., can be listed on back of sheet.
3. Overexposed negatives appear too light on proof sheet (frame 36); underexposed negatives appear too dark (frame 34). Remember that diagram explaining the negative/positive print system in the introduction?

developer and processing data, location, and perhaps a file number, so you can easily find the pictures when you've acquired a large number of proofed film rolls.

If you use an enlarger as your light source, set the enlarger's head high enough so that its projected light

3.

beam will cover an area large enough to accommodate the size printing paper you are using, and stop the lens down halfway—if it goes from f/4 up to f/16, use f/8. Try five seconds as an initial exposure time. If this turns out to be incorrect, you can either use a shorter or longer exposure time, as applicable, or open up or stop down the lens. Do not move the light source (enlarger head) closer to or farther from the paper, because this will change the area covered by the light beam—moving the enlarger head closer to the paper will result in a projected beam that doesn't fully cover the printing paper.

Use of the enlarger will be discussed more fully in the chapter on enlarging.

You might have noticed from the description of the proofing procedure that there's a difference between working with photographic printing paper and working with film. Because the paper is not sensitive to red or amber safelights, it is possible to work with it under safelight illumination, which allows you to see what you're doing during exposure and processing of the paper.

Since you can watch the image on the paper develop, you can pull the paper out of the developer when the image has reached the desired density; therefore, the strict time/temperature rules of film developing can be relaxed a bit when making prints. Since you can't watch the film image develop, it is essential to use time/temperature control to provide consistent results.

However, this does not mean that time/temperature can be ignored. Printing paper should be developed for 1½-2½ minutes (see the directions that come with it) for best results. If you overexpose the print so much that you must pull it out of the developer after 30 seconds to prevent the image from becoming too dark, the print will be of less than optimum quality. It will look splotchy, because it will be unevenly developed. Likewise, a print that is underexposed so much that you must leave it in the developer for six minutes will be of less than optimum quality. It will look dull and gray, not sharp and crisp as it should.

These effects are not so important in making proof prints, which are mainly made to check expressions and exposures, but they are of vital importance in making enlargements if one is interested in the goal of the print maker: Print Quality.

The developer temperature should be kept pretty close to 68°F. regardless of the type of print being produced, because the developer becomes quite inactive at temperatures much under that and overactive at much higher temperatures. □

Proof sheets and negatives can be kept in loose-leaf notebook for quick handy reference.

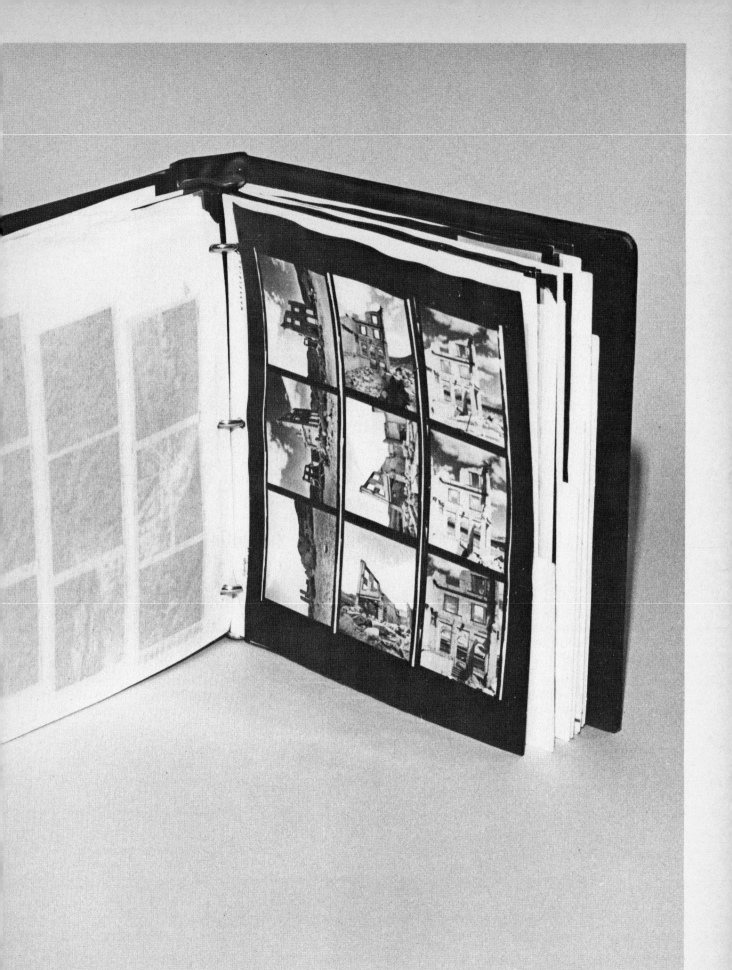

enlarging

The really fun part of darkroom work is making enlarged prints or "blow-ups" from your negatives. This is when you really see again the scene you saw in your camera's viewfinder.

MATERIALS

The equipment needed to make enlargements ranges from the very simple to the very elaborate. As is the case with cameras, the most elaborate and expensive equipment does not guarantee the best results.

ENLARGER—Let's start with the enlarger, which is, of course, vital to the process of making enlargements. An enlarger is a projector of sorts that shines a light through the negative, projecting the negative's image onto a sheet of light-sensitive photographic printing paper. This is why making enlargements is sometimes called projection printing—the negative's image is projected onto the printing paper, as opposed to contact printing, where the negatives are held in contact with the paper.

Most of the enlargers sold today are of the condenser type. In these, the light source is focused by one or more glass condensing lenses in the enlarger, concentrating the light evenly across the negative. The newest enlargers employ such things as mixing chambers to concentrate the light efficiently. The condenser enlarger is by far the most common type in use today because it gives a sharper and more contrasty print than the others.

Many brands of enlargers are available today, and most of them will give good value in return for your investment. As a general rule, you will get more versatility, convenience and efficiency from a more expensive enlarger. But not necessarily a better print—that is up to you.

My choice has been the Beseler 23C enlarger, for personal reasons, but Omega, Durst, Vivitar, Bogen, Minolta and Leitz all make very good enlargers. Your enlarger and its lenses will be your largest darkroom investment, so choose carefully and wisely before spending your money.

Some things to look for in

1

1. Enlarger is necessary item for making enlargements. The Beseler 23C is author's choice, but Omega, Durst, Vivitar, Bogen, Minolta and Leitz make very good ones too. 2. Drawing of enlarger head shows location of parts.

Lamp House

Enlarger Bulb
(Frosted or Clear)

Best Position for
Filter Drawer

Condensers

Alternate Position for
Filter Drawer

Negative Carrier,
Glassless If Possible

Bellows or Other
Focusing Device

Lensboard

Interchangeable Lenses

Enlarger head, showing location of parts. Note
position of filter drawer.

an enlarger: Will it accept all film sizes you intend to enlarge? Is it sturdily built, so it won't vibrate and thereby diminish the sharpness of your prints? If you intend to use variable-contrast printing paper, or ever do any color printing, does the enlarger have an above-the-negative filter drawer, so you don't have to hold your filters under the lens, where they might degrade the image sharpness? Are all the controls easily accessible?

LENSES—The best enlarger extant won't produce good prints if a poor-quality lens is attached to it. For many years, the Schneider Componon has been the standard of excellence in enlarging lenses. Many new lenses are making their appearance now—El-Nikkor, Rokkor-X and Fujinon and others of equal quality make your choice more difficult. Do not expect a lens in the $10-25 price range to give you the same quality that a $70-100 lens will give you. Your choice of lens and enlarger will have to be one of simple economics—buy the best you can afford.

A most important factor to keep in mind when buying a lens for your enlarger is the focal length of the lens. Those of you who own interchangeable-lens cameras will immediately have visions of choosing your enlarger lens as you do a camera lens—wide-angle, telephoto, zoom, etc. Relax. Enlarging lenses and camera lenses are different breeds. A very easy way to remember the proper lens to use in your enlarger is to use the same focal length as the normal lens on your camera (50mm for 35mm film, 80mm for 2¼x2¼ film, etc.). The focal length of the enlarger lens should equal the diagonal measurement of the film format being used.

The question then often arises, "If I take a picture

with a 200mm lens on my 35mm camera, what lens do I use on my enlarger?'' Stop a bit and remember that your film is still the same size regardless of the shooting lens—you'd still use the 50mm enlarging lens with 35mm film.

The only exceptions to this rule would be enlarging a small portion of a negative, or making a print smaller than the negative. Shorter focal length lenses produce greater degrees of enlargement, so you might use a 50mm lens instead of the normal 80mm lens to enlarge a portion of a 2¼x2¼ negative. Likewise, longer focal-length enlarger lenses produce less magnification, so you could use an 80mm lens with a 35mm negative to produce a smaller-than-contact print, if you should for some reason want to do that.

These statements about magnification and lenses are based upon a given position of the enlarger head. With the enlarger head set at a height that produces an 8x10 enlargement from a 35mm negative with a 50mm lens, changing to an 80mm lens will produce a smaller enlargement from the same negative. Raising the enlarger head (moving it farther from the printing paper) with the 80mm lens in place will eventually result in an 8x10 enlargement, but with the enlarger head farther from the paper, the intensity of the projected light will be less, calling for a longer exposure time.

Another point to understand about enlarging lenses concerns the f-stops. The f-stops basically work the same on enlarging lenses as they do on camera lenses—f/8 on one transmits the same amount of light as f/8 on another, and f/8 transmits more light than f/11, etc. However, as pointed out in the previous paragraph, to produce an 8x10 enlargement from a given negative using an 80mm lens, you'll have to

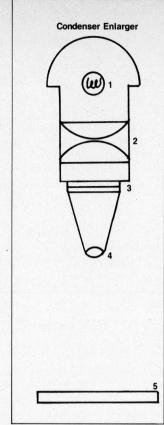

Condenser Enlarger

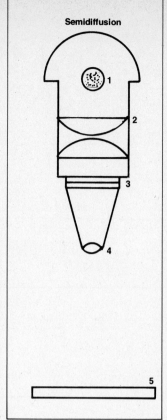

Semidiffusion

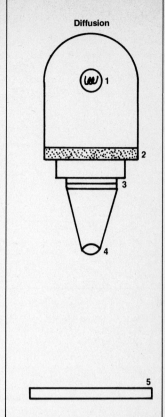

Diffusion

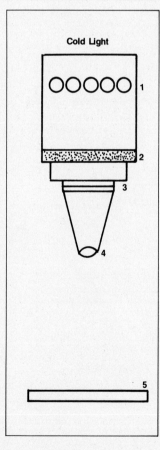

Cold Light

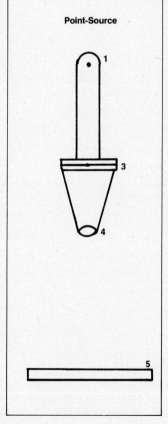

Point-Source

There are several types of enlargers; the condenser type is the best choice for general darkroom work. Enlargers work like this: Light from enlarger bulb (1) passes through condensers or diffusion glasses (2), then through the negative (3) and lens (4) to paper in easel (5). In true diffusion enlarger, only an opal or ground glass is used. Cold light enlarger may or may not use diffusion glass, and is not suitable for color printing. Point source consists of very small intense light source, may or may not use condensers, is special-purpose system. Drawings courtesy of PhotoGraphic Magazine.

move the enlarger head farther from the printing paper than with a 50mm lens; therefore if both lenses are set at f/8, less light will hit the paper using the 80mm lens, because the light source will be farther away from the paper. This is due to the inverse square law (as you move farther from a light source, the light intensity decreases inversely with the square of the distance from the light source), rather than to a variation in the f-stops from lens to lens.

One more point about f-stops: The maximum speed (maximum lens opening) of an enlarging lens is not as important as it is in a camera lens. You will normally be using the mid-range of the lens (f/5.6, f/8 and f/11). A wide maximum aperture is advantageous only in providing a brighter image for focusing, and in making very large enlargements, where the light source (enlarger head) is a great distance from the printing paper.

Why can't you use your camera lens on the enlarger? That's an oft-asked question. First, mounting the camera lens on the enlarger presents a problem. Second, and most important, enlarging lenses are flat-field lenses—they are designed to reproduce flat material with minimal loss of detail and distortion. Camera lenses are designed to be fast, and to reproduce three-dimensional scenes. Using a camera lens on the enlarger would result in unsharp prints. In fact, enlarging lenses are often used on cameras for copying flat subject matter, because they are so much better at it. A third consideration is some camera lenses can be damaged by heat from the enlarger lamp.

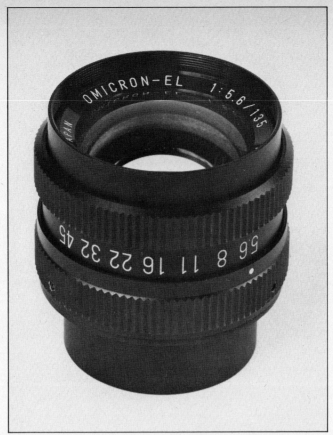

TIMER—Next in order of expense and importance is your enlarger timer. Since the enlarger deals in seconds and film developing is measured by minutes, the Gra-Lab timer is a good choice, for it is one of the few electric timers adaptable to both needs. The inconvenience of resetting the timer for each print you make forced most photographers to buy two timers for their lab—one repeating timer measuring seconds for the enlarger and another ''minute'' nonrepeating timer for developing film. Mechanical timers have been most popular for reasons of economy, reliability and convenience. Many new electronic timers are becoming available and are in many cases more versatile and quieter. Check features, costs, and your needs before laying out your cash. An enlarger timer should have the facility of being set at

Enlarging lens is rarely ''fast'' like camera lens, but it is designed to reproduce flat material with minimal loss of detail and distortion. Get the best you can afford.

from one to 30 seconds, a film timer from one to 30 minutes.

An electrical outlet to enable the safelight to be plugged into the timer, while not important, does make dodging and manipulation of the print far easier. Another option is a plug for a foot switch; this leaves the printer's hands free for dodging. Some of the new timers have such features as stop and start during the timing cycle and optional tenths-of-second settings. These are useful for some of

the advanced techniques explained in Petersen's *Guide to Creative Darkroom Techniques,* available at your local camera store or by mail order from the publisher. A large enough variety of timers is available to let you choose one that suits your pocketbook and needs.

EASEL—A good easel is neither a thing of beauty nor a joy to behold, but it should perform several duties well. It must hold your paper flat to retain the sharpness of your print. It must serve as a guide for cropping. It must not move as you place your printing paper in it. There are easels that leave no borders on your prints. There are easels that make one size of border only. There are easels that are adjustable on two sides and easels that are adjustable on all four sides, allowing you to print with any size border you wish. Another easel may be sprayed with an adhesive to hold your paper flat during exposure. My personal preference is the borderless easel made by Simmon-Omega. This easel holds your paper flat by using two adjustable bars to hold the paper, and leaves no borders. For those of you who are economy minded you may also elect to use a large pane of clean glass to hold your paper flat during exposure. This is somewhat cumbersome, but it is economical.

FOCUSER—The next item may be considered a luxury by some, but I consider it a necessity—a grain focuser. Please, may I repeat! *Grain* focuser, not to be confused with an image focuser—the magnification is the secret. This handy-dandy little item

is nothing but a mirror, ground glass, and a lens for magnification. Many, many of these are on the market and I have used most of them. The nicest of all is the Micro-Mega. The price may shock you (around $100), but it is extremely well made and works beautifully. Less costly but also very good are Scoponet, Paterson, Focuscope, etc. My personal recommendation is the Paterson for best in its price range. Beware of so-called grain focusers that are in reality ''image'' focusers (not so powerful or efficient). One clue to a true grain focuser is the reticle. The reticle is an engraved mark on the ground glass to help you adjust the focus for your own eyes. If you wear glasses in the darkroom, the true grain focuser may be adjusted for your individual prescription. Kinda nice for us ''four-eyed foto fans.'' Paterson even makes a large, super-tall grain focuser for those of us who sometimes like to make a really large print, 16x20 or 20x24 or larger. This focus aid is just a bit tall for making prints smaller than 11x14 size.

SAFELIGHTS—Since working in the dark would make it impossible to evaluate your progress, some form of illumination is necessary. This light must not harm your materials—hence, safelight. Again you have a myriad of choices ranging from a red bulb purchased at your local hardware store to the deluxe Thomas Safelite. Costs also range from a few cents to over $100. In an emergency situation even a ''bug'' light sold at most hardware stores can be used if it is kept at a proper distance. The safest color for a safelight is amber—most photo papers are made nonsensitive to this

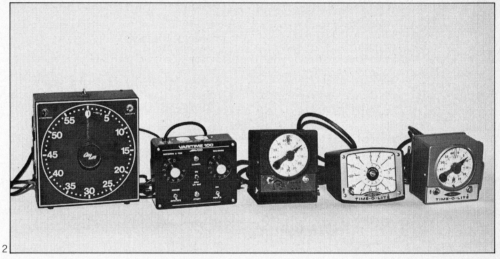

1. Enlarging area of author's school darkroom features various enlarger brands.
2. Enlarging timer should have provision for plugging in the enlarger and a foot switch for maximum convenience. Some have provision for safelight plug. Some of the handier timers are repeatable—they reset themselves after each exposure, which is handy if you are making a lot of prints from one negative. Gra-Lab model at left is highly recommended by author.
3. Be sure to keep a spare bulb for your enlarger handy. Nothing is more frustrating than having your only bulb blow in the middle of a printing sesion.
4-6. Easels come in many varieties. Ganz Speed-Ez-Els (4) and Saunders-Omega SLS Easels (5) are simple and and handy, but not adjustable; author's favorite is Omega borderless easel (6).

color. It is brighter to the eye than plain red and makes it easier to see what you are doing. The three basic types of paper normally used in photo darkrooms are contact paper (usually used for proof sheets), graded enlarging paper, and variable-contrast paper (more about these later). Contact paper is nonsensitive to yellow, amber and red light. Graded paper is nonsensitive to amber and red light. Variable-contrast paper is nonsensitive to amber light. Thus by brilliant deduction it would seem a good choice for all-round illumination would be amber—then you are free to choose any of these types of paper for your printing. Safelights should be brightest at your developing tray. This is the most important area, calling for judgment of print tones. The enlarger should be lighted as well as possible so you can find your materials to work with. Follow the manufacturer's recommendations as to distance from working area and check for your paper safety by making a simple test to be outlined later.

You may be interested in making your own safelight. After all it is only a filter with a bulb behind it. I use Mexican lamps with amber bulbs in them for safelights because they are decorative as well as functional. Add some class to your lab. They actually cost less than most safelights and serve the same purpose.

DODGING AND BURNING TOOLS—These (we will explain their uses later) may be made from the simplest

4

5

6

materials or purchased for a few dollars. To make your own dodger you need only a thin strong wire, such as a coat hanger, approximately 18″ long; tape a handle on one end and a cardboard circle of approximately one-inch on the other end. You now have a handy-dandy homemade dodger at a very friendly price. For a burning tool, a piece of cardboard with a hole in the center may be used very well. Since the shape of burning will change from print to print, this hole may be shaped to fit the occasion. More on this later.

SINK AREA—Let's leave our enlarger area now and go to the "wet" or sink area. If space permits, it is always a good idea to keep your enlarger and accessories separate from your trays and running water. Cleanliness and vibrations from running water are reasons enough. Since the most traffic will be between your enlarger and your developing tray, keep this distance as short as is practical. If your darkroom is a long room, you would soon get tired of exposing paper at one end of the room and racing to the other end to develop it!

Running water is *not* necessary in your darkroom. Sure it is handy to have hot and cold running water and a drain to get rid of it, but all operations that call for running water may be done in another area with the lights on. Washing, mixing chemicals, and cleaning up trays and equipment may all be done in another location entirely.

Those of us who wallow in luxury have both hot and cold running water and a drain to get rid of it. If this area is a bath or kitchen, which must be cleaned up after each printing session, you may lay a protective layer of plastic down first to avoid staining. The plastic may be a painter's drop

cloth or a sheet of plastic purchased at the local variety store. Now that you have protected the area from possible accidents, set out a minimum of four trays of convenient size. (I prefer the 11 x 14 trays for most printing to give me room to work.) Color-coded trays are nice but not essential. Three trays are for chemicals and the fourth is for water to store finished prints in until wash time. Get a minimum of two print tongs—bamboo with rubber tips or plastic. I do not recommend stainless steel tongs. Certainly they last forever, but I am always afraid of marking a print by holding too tightly or scratching the print with the tong. Two tongs are needed because you *never, never* allow your developer to become contaminated by splashing or carrying stop bath back into it. For this reason it is a good idea to use tongs of different colors to prevent forgetting which goes in the developer. If you have any control over the height of your working area, try to keep your tables and trays at your waist level to avoid straining your back to reach trays or enlarger.

MEASURING CUPS—An assortment of measuring graduates is handy (4, 16 and 64 ounces) as well as a funnel or two. These may be purchased at your local photo store or at a greatly reduced price at your grocery or variety store (an ounce is an ounce in any graduate). Let your pocket be the judge of price.

THERMOMETER—A good thermometer is a must. The thermometer you use for film processing will be fine.

WASHERS—Print washers may be the simplest (bathtub) up to my favorite, the Arkay 1620 Loadmaster. Both your budget and the number of prints washed will decide for you. To mention a few—De Hypo is a simple rubber device that covers the drain of your sink, with a hose to provide agitation. Kodak's Tray Siphon attaches to your tray to provide the same. Arkay makes a tray washer that provides excellent washing for a few bucks. Several manufacturers make a circular plastic washer, such as Richard. Paterson makes two sizes of upright washers for space saving. With the increased popularity of hypo clearing baths, the washer is used for much less time, thus saving time and water.

PRINT DRYERS—One of the age-old problems of darkroom nuts is how to dry prints. Not too many of us need or can afford the money or space required for the big floor-model drum dryers. We must economize on both a space and money. Simplest and least expensive are the air dryers—towels, blotter rolls, etc. Wiping or squeegeeing excess moisture off the prints, then laying them face down on a dry towel, then covering them with another dry towel is a very cheap way out. Next in order of cost would be blotter rolls. These can be made more efficient through the use of a cardboard box and a fan. Blotter books are not recommended except in dire emergencies due to the fact that almost no air circulation leads to prolonged drying times. With the advent of electric clothes dryers few of us have an outdoor clothesline to hang prints on with clothespins. I was never too fond of this method

1

2

4

3

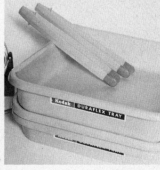

5

myself—nosy neighbors and excessive print curl are the main reasons why. Electric print dryers are not as popular as of old, the main reason being the recent

advent of resin-coated or plastic-coated papers, which we will discuss later. Premier, Arkay, Technal, and Burke and James all make very good flat dryers, varying in price and capacity. Roller drum types are available and

6

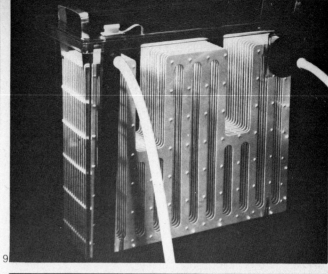

9

7

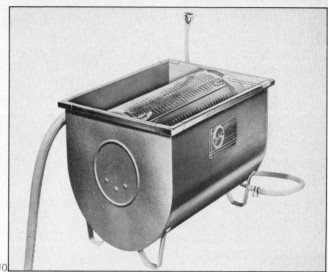

10

8

1. Author recommennds Paterson grain magnifier as best in its price range.
2. Safelight should have amber filter for maximum versatility. Safelights range from colored bulbs that screw into standard light sockets to elaborate $100-plus units. This is Paterson's safelight.
3-5. Plastic trays to hold chemicals should be large enough to permit easy processing of largest print size you plan to make. Print tongs will keep your hands out of the chemicals. Never use developer tongs in other chemicals, and never use tongs from other trays in developer tray.
6-10. Print washers come in all shapes and sizes, and prices. Kodak Tray Siphon (6) washes prints in water-filled processing tray. Ganz De Hypo washer (7) covers sink drain and washes prints in sink. Arkay unit (8) includes washing tray. Paterson washer (9) stands prints up during washing. Author's favorite is Arkay Loadmaster drum washer (10).

of course the tabletop continuous drum types such as Beseler, Arkay, Pako, Abdoo, Prinz, etc. are much more efficient—and costly. So ladle your desires with money and let your photo dealer have his day!

PAPERS—Now the time has come to talk of papers. You probably thought you had it made after choosing your camera, film, developer, enlarger, etc. There are so many choices in the field of papers that it is no wonder your local camera store has literally shelves of papers. The choices available are

incredible. Graded or variable-contrast. Conventional or resin-coated. Single weight, double weight, medium weight or document weight. Warm, cold or neutral tone. Black or brown tone. Paper surface. Let's consider the options.

1—Contrast. By print contrast, we mean the difference between the dark and light tones in the print. If we say a print has high contrast, we mean that most of the darker tones are reproduced as black, and most of the lighter tones are reproduced as white, with few gray tones in between. If we say a print has low contrast (or that it is "flat"), we mean that the darkest tones are dark gray (not black) and the lightest tones are light gray (not white). A low-contrast print generally has a "muddy" appearance. A good, normal-contrast print will contain some black tones, some white tones, and a full range of gray tones as well.

When printing a given negative, we can control the contrast in the print by using different contrast grades of printing paper. Standard graded printing papers come in various degrees of contrast, the grade number indicating how contrasty the paper is. For example, Ilford papers range from grade No. 0 to grade No. 5. No. 0 paper is a very low-contrast paper, used to print very contrasty negatives. No. 5 paper is a very contrasty paper, used to print very "flat" negatives. No. 2 or No. 3 paper is considered "normal" contrast. Agfa papers range from grade No. 1 to grade No. 6. No. 6 paper is extremely contrasty, and is generally used for special effects.

1

2

3

It should be pointed out that one paper manufacturer's grade No. 2 paper is probably not identical in contrast to another paper manufacturer's grade No. 2 paper—one paper is probably a bit more or less contrasty than the other. But within one manufacturer's line, a higher-numbered paper grade will always be

1. Among the least expensive ways to dry prints is blotter roll. Blotter books are not recommended by author.
2. Flat dryers, such as this from Heatrite, contain electric heater, dry prints quickly and efficiently.
3. Electric drum dryers are efficient and expensive.
4. Enlarging meter is accessory you might want someday.
5. If you choose variable-contrast printing paper, you will need a set of variable-contrast filters with which to control print contrast, but you will need only one package of paper for all your printing needs. Object between filter sets is a filter holder that attaches to enlarger lens, if your enlarger has no filter drawer built into it.
6-11. Perhaps the best way to get across what is meant by print contrast is this set of prints made on the various printing paper grades from No. 0 (low contrast) to No. 5 (high contrast).
12. You can use the same basic test for sufficiency of your darkroom's darkness as you did in the film chapter, only set the key on a sheet of printing paper for about three minutes, as explained in the text. If the paper shows evidence of the key, as this does, your room isn't dark enough.
13. By tearing an 8x10-inch sheet of paper into quarters, you can make four exposure tests with one sheet of paper. This test print is too light; more exposure is needed.
14. In this test print, the exposure is just about right.
15. This test print is too dark; less exposure is called for here.

4

5

8 #2

12

9 #3

13

more contrasty than a lower-numbered grade.

You might at this point worry that you'll have to buy an awful lot of paper in order to meet every eventuality. This would be true were it not for variable-contrast papers. The contrast of variable-contrast paper can be controlled by varying the color of the exposing light source (enlarger lamp) by using filters. Kodak and Du Pont, among others, make these papers and filters. Kodak's system is called Polycontrast, and the filters range from No. 1 through No. 4, in ½-step increments (1-1½-2-2½-3-3½-4). Du Pont's system is the Varilour system, and the filters range from No. 0 through No. 4 in full-step increments (0-1-2-3-4), with a No. 00 filter available on special order if you really want to flatten out the contrast.

Again, No. 2 (or 2½) is considered "normal"

6 #O

10 #4

14

7 #1

11 #5

15

contrast. Grade No. 4 with variable-contrast paper isn't quite as contrasty as grade No. 4 graded paper, but it should be plenty contrasty for normal needs.

To use variable-contrast paper, just insert the desired grade filter into the enlarger's filter drawer (or if the enlarger has no filter drawer, hold the filter beneath the lens), and make the print in the usual manner. To change the contrast, if you are unhappy with the result, just use a higher-number filter (for more contrast) or a lower-number filter (for less contrast).

2—Conventional or resin-coated. For a long time, printing paper has consisted of an emulsion coated on a paper base. Recently, some manufacturers have started coating the emulsion onto plastic instead of paper—resin-coated "paper." The resin-coated papers offer several advantages over conventional papers. They air-dry to a high gloss (or other finish, depending on the paper chosen) in a matter of minutes, thus eliminating the need for a print dryer. They wash sufficiently in but a few minutes, thus saving time and water. And they fix in less time than paper-based emulsions.

On the other hand, resin-coated papers are a bit more susceptible to damage

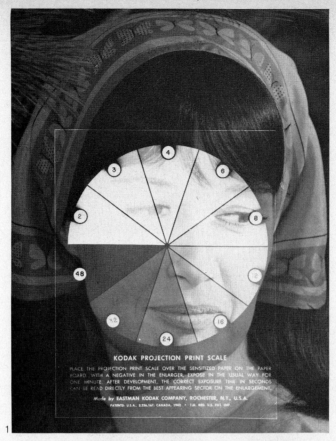

1

2

from print tongs, and they must not be fixed or washed too long or the emulsion will be damaged. But all in all, resin-coated papers are a great advancement in printing papers.

3—Weight. This refers to the thickness of the paper base. Single weight is the least expensive. Double weight is better for larger prints. Document weight is good for passport photos. Medium weight is somewhere between single and double weight.

4—Tone. The image on printing paper can be "warm" (brown to brownish-black), neutral (black) or cold (blue-black). Most photo stores have manufacturers' paper samples that show the differences. Look at the samples and pick the tone you like best. Perhaps you'll want warm-toned paper for portraits and neutral or cold-toned paper for other subjects. Look them over.

5—Surface. Papers come with different surfaces. Most common is glossy, a very shiny surface. Other surfaces are pebble, matte, semi-matte, silk, linen, tapestry and more. Again, the best way to determine which you like is to look at the samples at your local photo store.

Recommendation: Start your printing with a normal grade—No. 2 or No. 3— double-weight glossy or resin-coated paper in 8x10-inch size. Normal contrast is best because most negatives will print well on it, double-weight paper is easier to handle, and glossy or resin-coated paper is a good general-purpose choice. An 8x10-inch enlargement is a good and common size.

CHEMICALS—Possibly the most popular paper developer is Kodak's Dektol. I prefer Clayton P-20 paper developer, but due to its very limited distribution, I would suggest you use the paper developer most easily obtainable in your area.

1. Another method of determining proper exposure is Kodak Projection Print Scale. Put scale down on top of paper in easel, make one-minute exposure. After print is developed, correct exposure time is read in circle in best appearing sector on print; 16 seconds in this example.
2. When proper exposure has been determined, set timer and f-stop, put paper in easel, and use grain focuser to make sure the image is sharp.
3. Here, exposure is being made with Projection Print Scale in position on paper.
4-6. This is what print looks like as it develops, at 30-second intervals. Image might appear sooner if developer is warmer than 68°F. or with certain papers.
7. Trying to save overexposed print by pulling it out of the developer quickly (say after 30 seconds or so) results in this muddy, uneven look.
8. Trying to save underexposed print by leaving it in the developer longer than recommended time results in print like this. Some evidence of fogging (gray highlight areas) may show after long development.
9. Proper exposure coupled with proper development is the only way to produce a quality print.

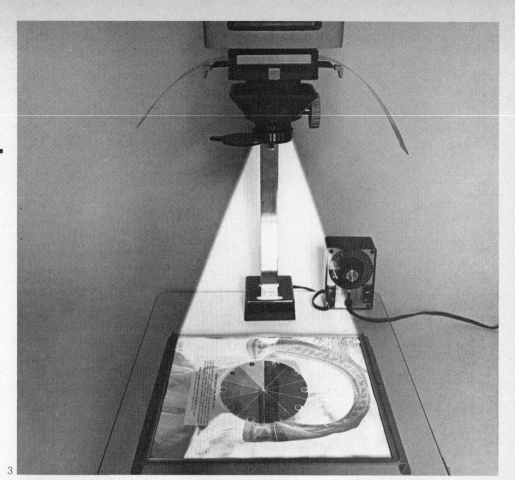

3

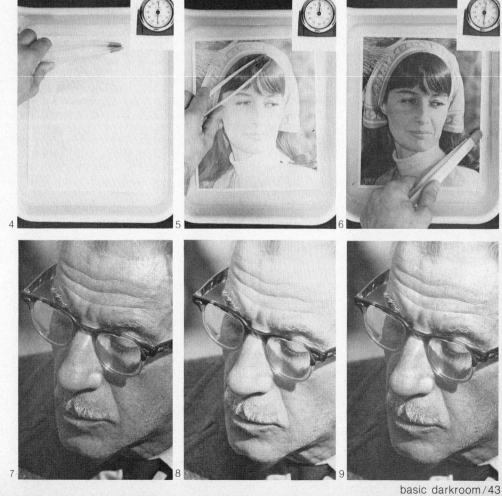

4 5 6

7 8 9

Don't use your film developer for paper—the two require different developers.

The stop bath, fixer and hypo eliminator discussed in the film processing chapter will work fine with printing paper, so you needn't buy different chemicals in these cases. You can make a stop bath by combining equal amounts of household white vinegar and water, but I prefer to use an indicator stop bath available in photo stores. This stop bath is yellowish in color (invisible under the safelight), but turns a powerful purple when it is time to mix a new batch.

Again, I recommend using liquid, rather than powdered chemicals. Consider the time and effort required to dissolve the powders, and the possibility of error and/or contamination of chemicals, and I'm sure you will opt for the ease and reliability of the slightly more expensive liquid concentrates.

If you don't use resin-coated paper, a print flattener is a good idea. This chemical contains glycol, which allows a print that has been soaked therein and then dried to later absorb moisture from the air to relax the paper fibers and minimize the tendency to curl. (Don't leave dried prints in a hot place, like locked in a car, or they will curl up.)

PROCEDURE

Mix the chemicals and pour them into their respective trays as you did for making proof sheets. Make sure you never put anything but developer in the developer tray. It might be a good idea to test your safelight, if you didn't for proof printing. This can be done as follows:

With only the safelight on, place a sheet of your enlarging paper in your easel and place a coin or key or something on it. (Make sure the paper is emulsion side up—the emulsion side is the

shiny side.) Place a board over the developer tray, then take a second piece of printing paper and write "D" on the back, and place it emulsion side up on the board with a coin, key or whatever on it. Wait five minutes, then develop both pieces of paper for a full three minutes. Put them in the stop bath for a few seconds, then fix both papers. Rinse in water, then, using a strong white light, examine both papers for signs of the object you placed on them. If either has any sign of a shadow of the object, you may determine which area (enlarger or developing tray) is unsafe by looking for the "D" on the back of the paper. If either is unsafe, move the safelight

about one foot away from the area and repeat the test. Most safelights call for a 15-watt bulb and must be used at least three feet from the working area.

Once you have determined that your safelight is indeed safe, you're ready to print.

With the white (room) lights on, you should place a piece of paper in your easel (the back of an old print works well) the same size as your intended print. Adjust your easel to fit the paper and hold it in place. Then dust off your negative and place it in your enlarger's negative holder with the emulsion (dull) side down and with the bottom of the image to the rear of the enlarger. Place the holder in the enlarger and turn off the white lights, and turn the enlarger on. By raising or lowering the enlarger head, you may fill the space on the

Cropping the picture— cutting out extraneous portions—can improve it.

paper in the easel to suit your taste.

In the interest of efficiency it is always good procedure to eliminate as many variables as practical. Enlarging, as in picture taking, has three variables—focus, time and lens opening. Focus the image, using the enlarger's focusing knob. Then try setting your timer at 8 or 10 seconds, and by opening or closing the lens aperture, varying the amount of light allowed to affect your paper. The more light the darker the

print; the less light the lighter the print. Focus by eye with the lens wide open. Then close the lens down gradually until the two darkest portions of the picture appear as the same dark tone. Turn off the enlarger and tear an 8x10 sheet of paper into quarters, replacing three of the pieces in the envelope or box for later tests. Place your roughly 4x5-inch test paper on the easel in the important part of the picture area and expose the paper for the time you have set on your timer (8 to 10 seconds). Develop the test print for 1½ minutes. Give it five seconds in the stop bath, then fix. After the test has been in the fixer for 30 seconds, turn on the white light and check your test.

Now is the time to judge your test: If your test print is *very* dark you must return to your enlarger and close the lens aperture one full stop. Nearly all enlarger lenses have "click stops," that is, at all full f-stops the aperture ring will click into place. Therefore, you need not peer up at your enlarging lens in the dark to check the f-stop. You may simply turn the ring on the lens until you feel it "click" into its next position. Since some lenses close clockwise and some close counterclockwise, you may turn on the enlarger during this operation to visually check if your image gets darker. One click or f-stop will give exactly one-half as much light or double the amount of light, depending of course on which direction it is turned.

After your corrections are made, turn the enlarger off and make a repeat test at the new setting. The second test should be very close to normal when checked with room light. For your final print, remember it is not

1

necessary to be exactly on the click stop. For more control you may use any position between these clicks, that is, half-stops or third-stops are sometimes needed for correct exposure. Obviously at this point if the test is too light just turn the aperture ring in the other

direction (allow more light).

The "moment of truth" is fast approaching. Just before making any print it is always a good practice to check your focus with a grain magnifier. Focus visually, then place the grain focuser on the easel and, looking through the glass, carefully adjust the enlarger until the grains of silver on the negative are crystal clear. When sharp, the silver grains will look like sand. Once you are certain of your focus, turn off the enlarger and place a full-sized sheet of paper in the easel with the emulsion (shiny) side of the

paper up. Turn on the timer and make your exposure. Following the same procedure as with your tests, develop, stop and fix. Oh! Happy day! It simply must be the greatest print ever made.

If you have trouble (as most people do) evaluating your print under the dim lights of the safelight try this tip: Take a print that under room lighting pleases you in tone and place it in a tray of water next to your developer tray. Under the safelight you

2

3

*1. Burning-in is done by
holding card with hole in it
between enlarger and paper,
so that light goes through
hole and hits only that area
of print that needs darkening.
2. Face is too light in this
print, needs burning-in.
3. Burning-in restores tone
to model's face.
4. If you don't keep burning
card moving, evidence of your
manipulation will show.*

now have a comparison to
help you judge your print
density. Since all prints
under the safelight will look
darker than under room
light, this will help you make
your decisions more easily
and rapidly. Remember a
large trash container will be
of utmost importance to
prevent you from saving
those prints that are
''almost'' good. It is most
disconcerting to find that you

have saved a print knowing
it wasn't the best you could
do. So! You have a trash
container full of bad prints.
You should learn from your
mistakes and correct them at
the time—not later when you
have forgotten how you
made them. Assuming that
you have a properly
exposed, developed, and
fixed print, you are ready for
the next step—cropping and
composing your picture.

Most of us when taking
pictures include too much
background and unwanted
junk in our pictures. It is
easy to crop or cut out
extraneous detail in the
enlarger. By raising the
enlarger you will get a larger
picture projected than your
printing paper will cover. By
moving your easel around
while the enlarger is on, with
the lens wide open, you may
select the portion you are
interested in. This is called
''cropping.'' (When raising
your enlarger you will also
have to increase your
exposure—a rough estimate
would be approximately one

4

f-stop wider open for each increase in size—8x10 to 11x14 to 16x20, etc.)

DODGING AND BURNING

Unfortunately, we cannot always control the lighting used to take pictures; therefore we will sometimes have to darken or lighten some areas of a print to make the print look as we think it should. To lighten an area we must hold back some of the light or "dodge." To darken an area we must add more light or "burn-in." Dodging is done with the coat hanger wire we mentioned earlier in this chapter. To keep the dodging tool from showing on the print we must work at approximately mid-distance between the lens and the paper. The dodger must be kept moving to avoid telltale shadows. Dodging is easier to do during your normal exposure. Burning is easier to do after the original exposure is done. To burn, make first a normal exposure for the entire print and then, without moving your paper, give the areas needing more exposure a second shot of light, meanwhile protecting the other areas with the cardboard. Care must be taken to avoid overdoing it. Burning and dodging must be done only when and where needed. If your finished print shows that you have manipulated it, redo it.

Do not burn or dodge a print unless doing so will improve it. If it helps, do it. If not, forget it!

Remember, no one can do more than start you on burning and dodging. Practice may not make you perfect, but it helps.

STABILIZATION

There is an alternative method to tray-processing your prints—stabilization. This tabletop operation makes use of a handy-dandy machine called a stabilization processor. An electric motor turns a series of rollers, which force your paper through two baths of chemicals—activator and stabilizer—in about 20 seconds. Great for space savers and hurry-uppers. All control of the print is now done in the enlarger. Stabilization calls for special paper and special chemicals to do its job.

SAVING GRACES

Have you noticed any marks on your print caused by tiny scratches on the negative? Unless extreme care is taken when handling film, it will scratch. The scratches will show on prints, and they require lots of work to retouch or spot. It's much easier to remove them before you start. Several commercial products such as Perma-Film and No-Scratch are available to remove scratches, but if you do not have them readily available there are several alternative methods.

First and usually handiest is called "nose grease." If you have oily skin you may rub the bridge of your nose

1. Dodging is done by holding dodger so that it casts shadow on portion of print that needs to be lightened.
2. Face area is too dark in this print, needs lightening.
3. Dodging lightens face area on print.
4. If you don't keep your dodger moving, everyone will know you used it.
5. Have a scratched negative? A little Edwal No Scratch applied to negative will hide scratch on print.

with a forefinger to collect skin oil, and by gently rubbing your negative *across* the scratch the oil will fill the scratch. The entire negative must be covered. Before printing the negative, carefully wipe all excess oil off the negative; again, wiping only *across* the scratch. If you have dry skin,

use Vaseline. Works great—for the scratch and for the skin.

Another way to remove scratches in your negative is to soak your negative in your tray of print developer for about 15 minutes to soften the gelatin, then dip the negative in water, then fix it normally. Wash and dry and you will discover the scratches are gone. The paper developer will soften and swell the emulsion of

your film and the fixer will harden it. In the process the scratches will disappear. The whole operation may be carried out in normal light.

After treating several negatives by this method, you will be more careful how you handle your negatives.

BLEACHING—One of the most common errors in shooting is not checking the background when taking the picture. Relax, this may be corrected in the darkroom. The trick that most commercial photographers use to remove unwanted details in the finished print is bleaching. You may buy the necessary chemical in a one-pound container or, for the small or occasional need, you may buy a packet of Kodak Farmer's Reducer. The chemical we refer to is potassium ferricyanide. The one-pound container will last you for years. The small packet of Farmer's Reducer contains one portion of ferricyanide and one portion of hypo crystals. You may use the ferricyanide (small reddish colored crystals) to bleach; discard the other packet and use your regular fixer instead.

To mix your bleach, use approximately one tablespoon of ferricyanide to a pint of water. When it's thoroughly dissolved you will have a very strong "stock solution." This may be used as is for very quick total bleaching, or it may be diluted for just lightening an area. Since this is not dependent on safelight conditions, the entire operation should be carried out in room light. A print that is freshly done or an older

print may be used equally well. An old print may be soaked in fixer for a few minutes and then bleached or a new print just finished may also be bleached.

Since ferricyanide is mildly toxic, it should not be handled with your bare hands. A cotton medical swab is an easy method of applying, and for very small areas a fine brush may be used. Since the ferricyanide will eat metal, tape the metal ferrule of the brush before using. This will keep the ferricyanide from attacking the metal. Ferricyanide is neutralized by fixer. It is also accelerated at first. *Go slowly.* Start with an old print until you get the feel of it.

Several small cups of different dilutions may be prepared and placed next to your fixer tray—one of straight "stock," one diluted 1:5, one diluted 1:10 and one 1:20 for different bleaching.

For bleaching areas in a large print, a cotton ball obtained at a drug store may be used with a print tong for easy application. Remove the print from the fixer and place

it on the bottom of a print tray or any piece of flat plastic. Wipe the area to be bleached with a disposable paper towel or napkin. Holding the print nearly flat apply the weakest solution of the bleach to the area being lightened. Care must be taken not to let the bleach run into areas you do not intend to bleach. After about 15 seconds the print should again be immersed in fixer to stop the bleaching. Remember to stop just before you think it is light enough, because the fixer will accelerate the action before neutralizing it. Holding the print too long in the air before returning it to the fixer will result in a yellow stain that is very difficult to remove. The process may be repeated until the proper amount of lightening has been achieved. To remove an entire background from a print you may use a wax pencil such as a china marking pencil to cover the areas you don't wish bleached. You may also paint these areas with Maskoid or Liquid Frisket. Both may be purchased from your local art store. After the bleaching, either of these products may be removed from the print by merely peeling it off the picture. The use of these protective coatings will also enable you to immerse the entire print in

1. Stabilization processor like this Agfa Rapidoprint is alternative to tray method, gives finished prints in about 20 seconds. These units use special papers and chemicals. 2. Shown are the items you'll need for bleaching prints: cotton balls, cotton-tipped applicators, potassium ferricyanide (available in small amounts in Kodak Farmer's Reducer packets). 3, 4. First step in removing entire background area via bleaching is to cover areas you don't want bleached with protective coating of Maskoid, rubber cement or marking pencil.

the bleach without affecting the rest of the print. Using a fine brush you will be able to bleach-out small areas or to protect them with Maskoid to bleach-out their surroundings.

Another method of using the bleach has been practiced for many years to give prints more snap and sparkle, and is known as the "Salon Treatment." Many expert printers whose work is intended for salon or other exhibition presentations will make their prints slightly darker than they would normally, then as a final touch, immerse the entire print in a tray of dilute

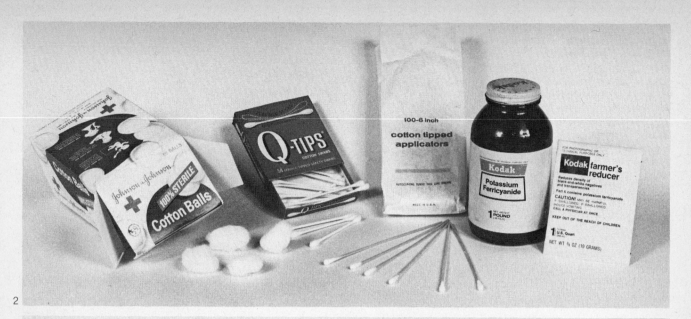

2

3

4

ferricyanide. This is done for a brief time until the highlights just barely turn white. This method gives a print an added brilliance that is hard to achieve any other way. Many other uses will suggest themselves to you as you establish your expertise in handling ferricyanide. You may add a small catchlight to eyes in portraits, you may remove wrinkles and pouches under eyes, and lighten the shadows that couldn't be printed otherwise.

After bleaching, the prints should be left in the fixer until all traces of the ferricyanide have been removed. The print must then be washed and dried by the usual methods.

INTENSIFYING—Sometimes you may wish to make an area of your print darker while it is coming to view in the developer tray. Try filling a coffee cup with hot water and placing a two- or three-ounce glass in the water to heat. When it is warm, pour some stock developer (full strength) in the small glass. Place the small glass in the coffee cup surrounded by hot water to keep it warm. A small brush or cotton swab may then be used to apply this warm strong paper developer to areas of your print during the developing cycle. During this application it is necessary to repeatedly dip your print in your regular paper developer to avoid oxidizing the developer and causing stains. This should be done quickly and may be repeated several times if necessary to darken an area that just isn't dark enough to suit you. As in bleaching this method will help you only after practice has given you the experience to confidently judge the times and necessity for the usage.

A good print is judged by many criteria, and differently by different people. Every print should have a black

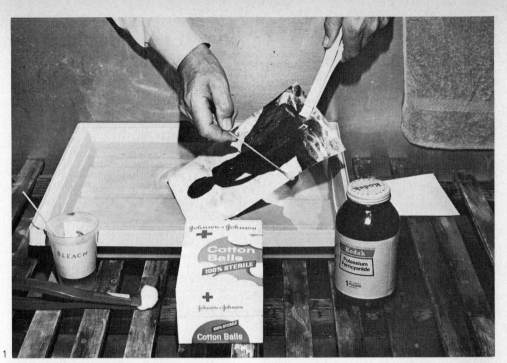

1

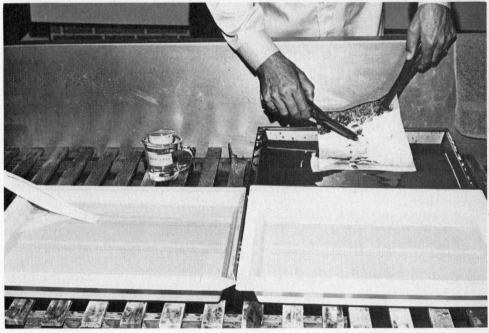

2

and a white. The black should be pure black and not gray. The white should be nearly pure white. The tonal scale between these extremes should produce a print that when viewed from a distance of 10 to 15 feet will retain a fully readable print. If, when viewed from this distance, too much detail is lost, you need to reprint. Remember also that the human eye is always attracted to a light area. Make sure your print brings the eye to the most important area and holds the attention. Basic composition rules should be kept in mind

and violated only when the subject is strong or different enough to warrant such a rule violation. Remember that these rules apply to most average situations, so break them only when absolutely necessary to achieve your purpose. Be very sure the rule-breaking is really needed and not just to show your own independence. ☐

1. Once coated, the entire print can be immersed in the bleach solution. Bleach is worked into print with cotton-tipped applicator.
2. To intensify print, keep small jar of developer in jar of hot water handy. This hot developer can be applied to developing print with cotton-tipped applicator to darken areas that need darkening.
3. Here's print with the background bleached out.

3

print finishing

Have you ever noticed how quickly those beautiful prints you have slaved over find themselves relegated to a drawer, or even worse, the waste basket? This can usually be traced back to those telltale specks of white on the print caused by dust, lint or hair on the negative. These dust spots are best avoided by cleaning the negative before printing it—removing dust with a Staticmaster brush, and if necessary, removing other residue with film cleaner.

However, if these white specks adorn your prints, due to sloppiness in the darkroom or whatever, they can be removed through a process known as *spotting*. A print is not really finished until it has been cleaned up by removing flaws such as dust specks. Print spotting could also be called "photographic cosmetology" because it involves covering certain flaws and emphasizing good points, just as make-up involves covering up flaws and emphasizing good points on a model.

The human eye is attracted to light areas on a print much more quickly than to dark areas. Since spots caused by dust, lint and the like on the negative appear as light specks on the print, the human eye is immediately attracted to them, and no matter how sharp and crisp the print is, no matter how fantastic the subject is, the viewer will remember his first impression—dust specks. So they must be removed.

2

3

Dust spots on the print can be removed by several methods—pencil, brush and, in extreme cases, the old reliable trash can. The pencil, though widely used in European countries, is not too popular in the U.S. The usual remedy here is the use of either spotting colors of various hues, or a dye. The dye is my favorite method because of its permanence and ease of application.

MATERIALS—For print spotting, you'll need some spotting color or dye (I use Spotone #3—neutral black), a #00 or #000 brush with a very fine point, some household ammonia, a magnifying glass on a stand or a visor-type magnifier, a good light source, a piece of an old rejected print to practice upon, a print you want to keep that needs spotting, and an uncluttered working area.

PROCEDURE—Set up the working light at an angle that provides good illumination, but no glare. Lay your equipment out so that it is easily accessible. Practice first on the reject print. The most common error in spotting is getting too much dye on your print. A quick

application of ammonia with a cotton swab will usually remove a too-heavy dye application, and you can work on another area of the print while that area dries. But get the feel of the process on a reject print before starting in on one that matters.

Shake your bottle of Spotone and remove the cap. Place the bottle in a safe place to avoid spilling, and use the cap as your working source of dye. It takes a *very small* amount to work with. Moisten the brush slightly on the tip of your tongue. The saliva provides a wetting agent to allow the dye to flow smoothly onto your print. If you don't want to use your tongue, you can use a drop of wetting agent (Photo-Flo, BPI-40, Beseler Ultra Wet, etc.) mixed with a drop or two of water instead. Use a very nearly dry brush just touched to the spotting color. It is always best to make the first application too light and build it up by repeated applications. Very light areas will take a single application, and darker areas may take several applications.

If the neutral black tone of the Spotone doesn't match the tone of your printing paper, the dye comes in other tones, and these can be mixed to produce just about any tone you'd need to match the tone of your paper.

You'll get best results if you pick up a little dye on the tip of the brush, twirling the brush to form a fine point, and apply the dye by using a stippling motion, making a series of dots with the brush, rather than trying to ''paint'' in the area.

O.K., now you know how to remove light areas from the print—with practice and patience and the steps just

outlined. But what about dark areas? Little pinholes in the negative let a lot of light through to the paper when you're making a print, and the result is little black spots on the print. If you find any of these on your prints, you can eliminate them by scraping them very very gently with an X-acto knife (ever try to shave a balloon?). Don't dig into the emulsion, just scrape very lightly until the black spot has lightened to the desired tone. Again, it's better to scrape too little than too much, so don't try to scrape away the whole black spot at once—remove it gradually, in thin layers.

Close-up portraits of people can be horrifying. Most of us after the age of about 10 start building character lines in our faces. Young people call these wrinkles—older, more mature people call them character lines. Whatever you call them, they simply are not flattering. To be kind to people, a wee bit of cosmetology is not to be

2

1. A few strokes of spotting brush will take care of shiny spots in corner of eye.
2. Easiest way to mount prints is with mounting adhesive and mounting roller. Scotch (3-M) and Kodak make adhesive; Technal makes good roller.
3. To use adhesive, lay print face down on newspaper or cardboard and spray its back. Spray surface of mount board.

3

scoffed at. Wrinkles consist of shadows in the creases of skin and highlights on the surface. If you darken the light areas to nearly match the tone of the creases, by means of spotting, you will remove years from the photographic age of people.

Eye surgery: The human eye must have moisture as a lubricant. Unfortunately, this moisture reflects light and makes for shiny corners of the eye and bottom sides of the center of the eye. A few strokes of the spotting brush, though, and—beautiful!

MOUNTING

Let's give these prints some class. Let's mount them on boards so they won't curl and, most important, to make them easy to display. Electric dry-mounting presses are the easiest, simplest and most expensive way to mount prints. The directions supplied by the manufacturers make them easy to use. Seal, Technal, and Kindermann, to mention a few, utilize a heated platen to apply both heat and pressure to a sandwich of print, mounting tissue, and mount board to seal them together.

Several less expensive alternatives present themselves. First and easiest is a product of 3-M or Scotch called Photomount. This is an adhesive supplied in a spray can for mounting

photos. To use, lay your print face down on a newspaper or cardboard and spray the back. Spray the surface of the mount board. Allow to dry for a minute or two, then very carefully, starting at one side, attach the two together. Roll the print with some type of roller to insure a complete bond and trim the edges. You have a mounted print. If you wish to leave a border around your picture you may mask off the mount board with paper to keep the spray off the border area. Kodak also sells a mounting cement in a tube. Large prints may be mounted to Masonite, plastic, wood etc. using wallpaper paste available at your local hardware store. Using this method it is easier to mount the print while wet. While it is drying the edges should be clamped to keep the print from shrinking too much, causing warping. Most glues and mucilages will not work to mount prints because they will stain the prints. Rubber cement should not be used for the same reason. The sulfur contained in these glues will in time react with the photo emulsion, causing stains that cannot be removed. Most of the "white" glues will work well if diluted with water to a more workable consistency.

The most common type of mounting is called "salon mount." This means locating the print on the mount board so top and both sides are equally spaced, leaving a wider space at the bottom of the print. An easy method of measuring the border to match your print size is: Line up your print with either side of the mount board. Place a

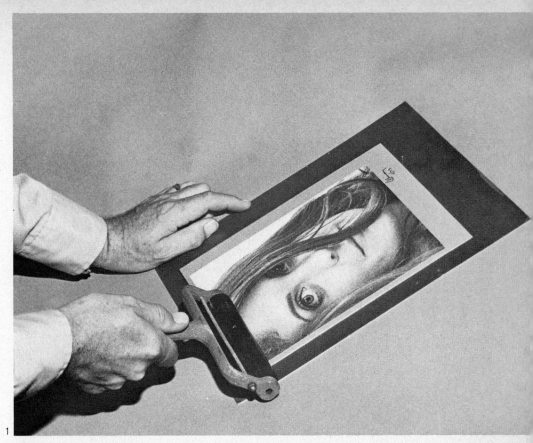

piece of scrap paper against the edge of the print and mark the distance to the edge of the mount board. Fold the paper in half and you have a measure to use. This measure will give the distance from top and either side to make a so-called salon mount. Your prints and mounts are not always displayed to their best advantage by salon mounting, so use the method best suited to each print individually. Before attaching the print to the mount, place your print on the mount and by moving it around you may decide another mounting will more effectively set it off.

Colored mount boards should be used only when they complement the photo. You may also buy precut mat mounts for your photos. These come in a wide variety of sizes and colors. They are usually made of two pieces of mount board. One forms a base and the other provides a cutout

frame for your photo. Most of them are attached on one edge only, making it very easy to insert your print, locating it and taping it in position.

Many methods of hanging mounted prints are available. These may range from a large nail to Scotch tape and sticky chewing gum. One of my favorites is called "Art-Blocks." These are small adhesive blocks attached to the back of your mounted print. They provide a ring to hang on the wall as well as a spacer for the bottom of the print. These are quick and easy to use and may be purchased from your local photo or art store. They sure save a lot of time when you have several prints to hang. □

1. After allowing print and mount board to dry for a minute or two, carefully attach the two together, then roll flat. Simple roller like this is sufficient for adhesive mounting; Technal electric unit shown in page 57 photo is for mounting tissue. 2, 3. To measure borders for salon mount, locate print at side of mount, then set piece of scrap paper against print, and mark position of edge of mount (2). Fold paper in half, and use as measure for top and side borders.

2

3

advanced film techniques

Don't read this chapter until you've pretty well mastered what we talked about in the chapters on processing film and enlarging, or you'll wind up confused instead of enlightened.

Once you've mastered the basics of developing film and making prints, you'll find that doing just that will keep you busy and satisfied for quite a while. But sooner or later, you're going to either encounter special situations or want to try new things you hear about or read about—and that is what this chapter is all about.

A basic axiom of photography is that exposure determines the density of a negative, and development determines how contrasty the negative will be. This concept is fairly easy to understand. If a negative is grossly underexposed, you can develop it all day and you won't get an image, because the developer can't develop the latent image unless the film has received enough exposure to form that latent image. Likewise, if the film has been exposed sufficiently, even a very brief trip through the developer will result in an image. So exposure determines the density of the image.

For years, photographers who use view cameras and sheet film have put their knowledge of this axiom to work for them. When confronted with a contrasty scene, one in which the bright areas of importance are much brighter than the dimmer important areas, these photographers give the film additional exposure in the camera to make sure that sufficient detail is recorded in the dimmer areas, then they cut down the developing time of the film, to reduce the contrast—the difference between the brightest areas and the dimmest areas. In this way, they obtain a negative that will produce a print that contains detail in both the bright and the dark areas of the scene, whereas by employing normal exposure and development techniques, they would have produced a contrasty negative that would produce a print lacking in either highlight (bright area) or shadow (dark area) detail.

Of course, some scenes are so contrasty that they are beyond the limits of the film's ability to reproduce detail in both bright and dark areas. And while film can record detail in areas some 140 times brighter than the dimmest areas they can record detail in, printing papers can reproduce detail in areas no more than about 40 times brighter than the darkest areas in which they can reproduce detail. So even when using the axiom, ''Expose for the shadows; develop for the highlights,'' you will run across some scenes in which you just cannot record detail in both bright and dark areas.

But just to see how far you can go in this direction, go out and shoot a roll of

1. Negative for this night scene received standard development, resulting in the usual night photograph appearance.
2. Reducing developing time or using compensating developer will flatten out night scene's excessive contrast, providing more detail, if this is what you want in your print.

Kodak Tri-X or Ilford HP4 film on a contrasty subject—say a lighted building at night—and give it two to eight times the exposure recommended by your light meter. Then develop the roll for only 50 to 70 percent of your usual developing time. While you're out shooting that building, expose a second roll of the same film at the reading indicated by your light meter, and develop it normally. Then make prints from the two rolls and compare them. The results will be enlightening.

Since you probably use roll film (35mm or 120), you can't quite tailor your processing to each scene you shoot as the sheet film photographer can, because you will likely have several scenes of various contrast levels on the same roll of film. But, with a little planning, and a little experimentation, you can customize your processing to get the results you want. In summary: You can reduce the contrast of contrasty scenes by reducing your developing time, and you can increase the contrast of "flat" scenes (those lacking in contrast) by increasing your developing time.

You can, of course increase or decrease contrast in a print by using a more or less contrasty paper to make the print, but if you want maximum shadow detail in a contrasty scene, you'll get better results by using the increased exposure/decreased development method. Then

again, perhaps the reason you shot the scene in the first place was you liked its high contrast—as with other areas of photography, you have to think about what you want in the finished print, then determine what you must do to achieve it.

COMPENSATING DEVELOPERS

You will undoubtedly read or hear about compensating developers somewhere along the line. Right here, for example.

When development begins, there isn't too much difference in density between the denser and less dense areas of the image on a negative. This difference increases, however, as development progresses. The longer the film is developed, the greater this difference becomes. That's what we were talking about in the last section—increasing development time increases contrast, and vice versa.

A compensating developer is designed to exhaust itself rapidly in the areas where exposure is heavy (denser areas of the negative), but to exhaust itself less quickly in the areas of less exposure (less dense areas of the negative) so that it keeps working on the less dense areas after it has stopped working on the denser areas. In this manner, it reduces the difference in density between the densest areas and the less dense areas of the negative—it reduces contrast.

This action is the reverse of normal developers—with compensating developers, the contrast decreases as the time of development increases—something to bear

in mind when trying to control contrast in your pictures.

TWO-BATH DEVELOPERS

In two-bath developers, there are two solutions, and the film is first immersed in one, then in the other.

The first solution is a developer without an alkali or activator, and during immersion, the film absorbs developing agents only. When the film has absorbed all the developer it can hold, nothing further happens, so the amount of time spent in the first solution is not really critical, nor is the temperature of the solution.

The second solution contains the activator, or alkali. When placed in this, the developer-saturated film reacts with the activator, and the film develops until the solution it absorbed is exhausted. The developer acting on the denser areas of the image usually exhausts itself before the developer acting on the less dense areas, so the two-bath developer is basically a form of compensating developer. Again, time and temperature are not critical, because the developer absorbed by the emulsion can work only until it has exhausted itself—there is no new developer in the second solution to be brought into contact with the negative. It is a good idea to keep the first and second solutions at the same temperature to prevent the film emulsion from swelling or contracting when transferred from one to the other.

While two-bath developers are pretty much "automatic," they don't lend themselves well to customizing your development as do normal developers, because of this very quality.

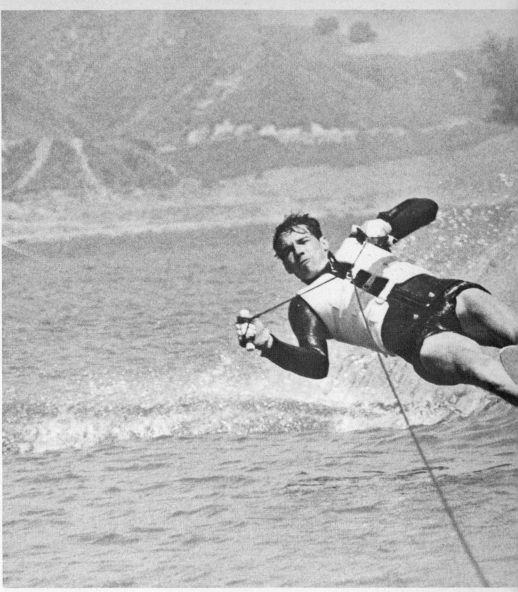

1

PUSHING FILM SPEED

If you do a lot of available-light photography and/or action photography, you'll probably be interested in push-processing.

If you underexpose your film by one f-stop (i.e., set the light meter for twice the film's ASA speed), and then develop the film for 50 percent longer than the normal developing time, you'll get contrasty but usable negatives, and be able to use one shutter speed faster or one f-stop larger for your shooting.

There are several developers on the market (Acufine, Ethol UFG, etc.) whose manufacturers recommend that you rate your film at two to six or more times its rated ASA speed when using these developers, and you might

1. Pushing film speed isn't just for low light level photography. Here, Tri-X film was pushed to allow use of 1/1000 shutter speed at f/22 to compensate for bouncing boat photographer shot from, and provide depth of field with 200mm lens.
2. Compensating developer like Ethol TEC reduces negative contrast, is good choice for developing negatives of contrasty scenes.

want to try these if you do a lot of available-light work. Follow the manufacturer's instructions as to exposing and processing the film, and see how you like the results.

Pushing film speed works best with scenes of low contrast—those where the difference in brightness between the brightest and dimmest areas of importance is not very great. If the brightest parts of the scene are not much brighter than the dimmest parts, you'll get detail in both. If the scene is very contrasty—the bright areas are a lot brighter than the not-so-bright ones—you'll get detail in the bright areas, but not in the dimmer areas.

As with so many areas in photography, the only way you'll be able to tell if pushing film speed is for you is to try it.

FINE-GRAIN DEVELOPERS

We haven't talked much about grain, but by now you've probably discovered it. As you recall from earlier discussion, the images on your film, and the images on your paper, are made up of little clumps of metallic silver. The darker areas are bigger, denser clumps; the lighter areas are composed of smaller, less dense clumps. We're not too concerned about the clumps on the paper, because they're all pretty small in relation to the size of the print, and their relative size decreases as the prints become bigger. But the clumps on the film—they're our concern here.

It seems that, to gain their increased sensitivity to light, the faster films use larger clumps. These clumps are called "grain." When a 35mm negative is enlarged to an 11x14-inch print, the grains, along with the image, are enlarged some 100 times. If a fast, large-grained film is used, the grains or clumps are visible. You can see the clumps that produce the image as you look at the print.

Sometimes this is not objectionable. If the print is to be viewed at a great distance, perhaps the graininess won't be noticeable. If you are trying for a grainy effect deliberately, to create a certain mood, you might use a very fast film like Kodak 2475 Recording Film, which has a speed of 1000 and more, and has grain a wheat farmer would be proud of.

But generally, we find grain disturbing. Much thought has gone into the quest for finer-grain films. Today's fast films (Tri-X, HP4, etc.) are not as grainy as yesterday's slower films. Some printers make 16x20-inch enlargements from 35mm negatives for display. Grain isn't nearly the problem it once was. But this statement doesn't do much for you when you are confronted with a print of your best guy/gal that looks more like a close-up of Malibu Beach.

By the time you have a grainy print in your hand, it's too late to employ fine-grain processing techniques on the film, but all is not lost just yet. For one thing, you can remake the print on a textured or silk surface paper. This will hide some of the grain. You can make the print using a diffusion type enlarger, if one is available,

2

2

1. This is what grain looks like. A 2475 Recording Film negative was printed on high-contrast paper to produce this effect. Note that no grain is visible in solid black or white areas; grain appears only in gray areas.
2. This was also blown up from a 2475 negative, but it was made on No. 1 (flat) paper, which deemphasizes graininess of this film.

or you can use a piece of stocking or a diffuser like the Arkay PicTrol to diffuse the image. Print on a soft (low-contrast) paper, as this will deemphasize the grain. Contrasty papers emphasize grain—if you print your 2475 Recording Film negative on Agfa No. 6 paper, you'll get spectacular results if graininess is what you want.

But we are assuming that you don't want grain. And the title of this section is fine-grain developers. So, a fine-grain developer is a "lazy" developer. While most developers are rather energetic, they tend to produce larger grain. Fine-grain developers, being a bit more lethargic, produce smaller (finer) grain. Unfortunately, they also tend to produce a bit less film speed.

If grain is a problem for you, you can try a fine-grain developer and see if you like it. Kodak Microdol-X works well with Tri-X, with minimal speed loss. The film manufacturer often recommends a developer for finest grain. Buy it and try it, and if you like it, you will reap benefits from your grain crop.

Incidentally, overexposing your film produces more grain, too, so meter carefully.

A last thought—since grain is visible only in gray areas (there is no grain in white areas, and black areas are so dense that you can't differentiate between individual grains in them), as a last resort you can, if you don't like the muddy result of using a flat (low-contrast) paper for the print, go to the other extreme and make a litho internegative (see Petersen's *Guide to Creative Darkroom Techniques* for details), and make a print that contains only black and white, with no gray tones. Then you'll have no grain, but your portrait subjects won't be very happy.

FINAL ADVICE

No matter what developer you choose to use or experiment with, always use it according to the manufacturer's directions the first time or two. That will give you results, and a reference point for your experiments. And by all means, experiment. You'll discover all kinds of things that way, some good and some disappointing, but you'll learn and advance in your skills.

There are so many variables in film processing and print making that the manufacturer's directions can only be a guide for you. The manufacturer doesn't know exactly what kind of tank you process your film in, what kind of water you mix your chemicals with, what kind and how accurate a thermometer you have, what kind of enlarger you use, etc. But he can give you a guide, a starting point. And since he is good enough to do that for you, use that guide as a starting point. That's how you learn. □

potpourri

A print of a beautiful golden sunset taken in black-and-white and printed to a white blob becomes dull, insipid, boring. Hold on! All is not lost. Have you ever wondered how to convert your black-and-white shot of a beautiful seascape into something more colorful? A beautiful green landscape from black-and-white, etc.

Try toning for a different approach. Bright yellow and red sunsets. Deep blue seascapes. It isn't so tough to do. How about creating a modern antique? All are possible with a few chemicals and a little time.

Many companies sell the chemicals used for these purposes, called toners: Eastman Kodak, Edwal, Rockland, G.A.F., Beseler, etc. Many common household items may also be used for this purpose—coffee, tea, food coloring, and vegetable dyes. Each produces a different effect.

Any black-and-white print, even a print that was made some time ago, may be treated to a whole new dimension through the use of a few simple chemicals.

Let's take the modern-day antique for our first trial. Any thoroughly washed print may be soaked in double strength cold coffee. Not the instant type, but double-strength boiled coffee. Soak the print *overnight* in the coffee, face down, being careful not to

Some of the various print toners on the market include (from left): Edwal yellow toner, Rockland red and green colorants, Kodak sepia, brown, rapid selenium and blue toners.

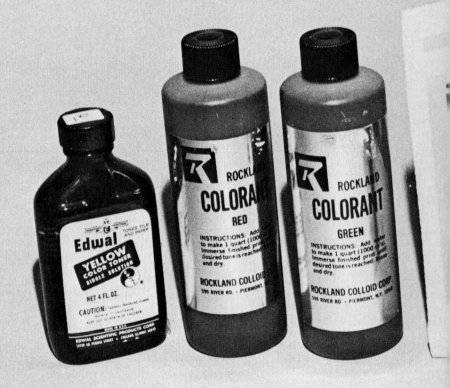

let prints stick together if doing more than one. Next morning, merely rinse in water and dry. Behold! Instant antique! Not too much trouble for you, I hope. Tea also works, for a different tone—not quite an antique, but if the tea is strong enough you will get an old look. If your photo is posed carefully, it will be hard to tell it from one of the old, old, funky photos found in family albums. Instant antiques are now quite popular at fairs. Most of these are merely Polaroid snaps, carefully staged and then sponged with GAF Instant Sepia Toner. Got a Polaroid? Make your own antiques.

Rockland also sells small aluminum pieces treated with photo emulsion. These are called "Silver Minnies" and may be treated with gold toner also furnished by Rockland. These can be printed in your own darkroom to give another type of antique. When framed, they resemble tintypes. Food coloring and vegetable dyes are sometimes used to tone. They have a bad habit of fading very quickly unless treated with the hardener

1. Rockland Silver Minnies are 3x4-inch aluminum pieces coated with photo emulsion. These can be treated with Rockland gold toner to give antique appearance.
2. If you print a color negative on regular black-and-white paper, you'll get results like this. Model Chris's blue eyes printed too light, while her lips and red dress are too dark. Print has grainy appearance.
3. Printing color negative on Kodak Panalure paper restores normal appearance.

from fixer for a few minutes.

Toning with most toners is very simple and easy. Always start with a thoroughly washed print. This will help keep the print from staining later. The toner may react with any residual fixer left in the improperly washed print. Some toners will not work unless a soft-acting developer is used to develop the print. Selenium toner is one of these. Some toners react primarily to the developed silver in the print, thus only coloring the dark portions. Other toners react primarily to the light areas in the print, leaving the dark areas unchanged. Toning instructions here are really useless, because the instructions packed with the materials are very adequate. Follow the manufacturer's directions and stay out of trouble. "Split-toning" or toning several areas of the same print different colors is a very easy variation. Rubber cement that has been thinned with thinner can be painted on a dry print to keep the toner from affecting the painted areas. After toning, the rubber cement may be rubbed off. Dry the print and repeat the process, this time covering the tones and coloring a different area. Thus you may turn a black-and-white print into a color print. The appearance is very similar to the old Kodak Flexicolor process, which is no longer available.

We have made color prints from black-and-white negatives with some

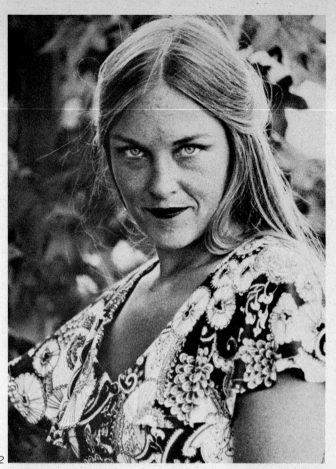

2

3

success, now let's reverse the process and make black-and-white prints from color negatives. There are only two things our lab needs that we don't already have. Either a #10 or #13 safelight filter (either one is O.K.), and a panchromatic paper. These papers are made by both GAF and Kodak. The Kodak paper is called Panalure and is available either in single-weight glossy or double-weight matte. The paper differs from conventional paper in that it is sensitive to all colors (hence the name panchromatic). Regular enlarging paper may also be used for this purpose, but remember regular paper is

When camera is tilted up to shoot picture of ruins, apparent distortion results.

insensitive to red and amber, so these colors will not register and the results are really weird.

How about converting your color slides to black-and-white prints? This can be done by a long involved process of first making black-and-white negatives and then using them to make prints, or by using one of the new resin-coated papers to do it simply in your enlarger. Flop your color slide in the negative carrier to make a backward negative print of the slide. This print, when dried, may be contact printed on another sheet of the same paper to make a positive print.

Distortion correction: Look up at a tall building and you will notice that the higher you look, the narrower the building appears. This is normal perspective, and if you take a picture of this

Distortion can be corrected by tilting easel when making print. Raising side of easel on which bottom of photo is projected reduces its size relative to top.

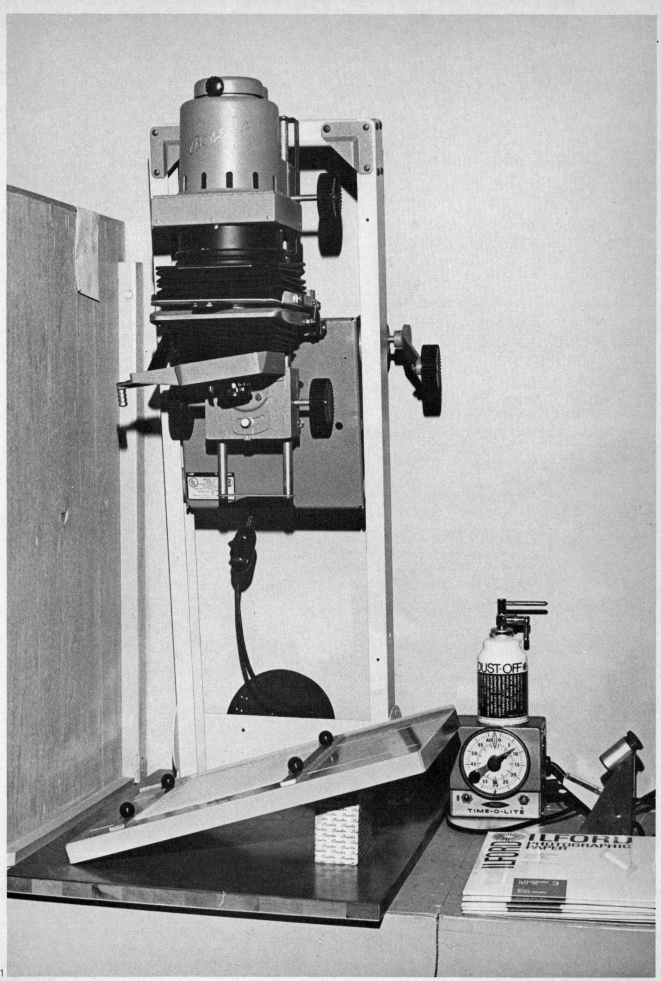

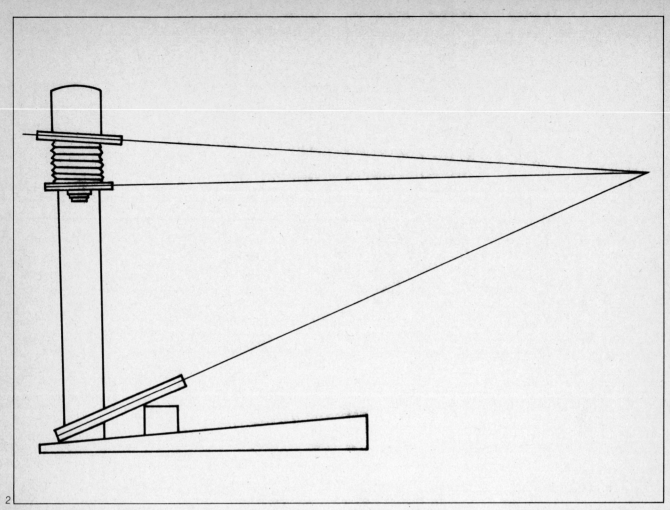

2

1. *If your enlarger has the ability to tilt lens board and/or negative stage, image will be sharper due to the increased depth of field.*
2. *Depth of field is greatest when lines drawn through lens plane, negative plane and easel plane all intersect at one common point. That's why enlarger with tilting lens board/negative carrier is best for correcting distortion.*

building, in it the rectangular building will become a pyramid. When looking at this print our brain tells us it is a rectangle but our eye sees it as a pyramid. The print just isn't believable. We must correct this apparent distortion so the viewer of the print will believe the building is actually rectangular. A few enlargers have either a tilting lensboard or a tilting negative carrier, thus making the entire process much easier. Since most pictures are taken without this distortion problem, many enlargers do nothing to provide for image correction. If you're blessed with one of these enlargers, have no fear—you can improvise.

As you will recall from the chapter on enlarging, the closer the easel is to the lens, the smaller the image. You can use this to your advantage when correcting distortion. If you raise the side of the easel on which is projected the base of the "pyramid"—the bottom of the building—you can reduce the size of the bottom of the building relative to the top.

Of course, if you raise one side of the easel, the image projected on that side of the easel goes out of focus. This can be handled in one of two ways. Most effective is tilting the lens and/or

(Text continued on page 80)

1

2

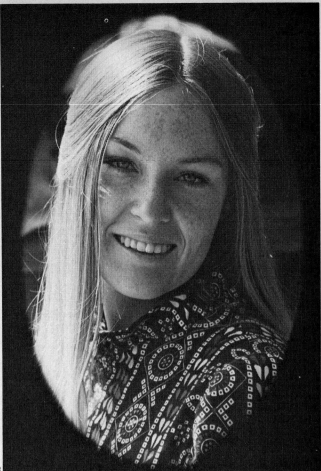

3

1, 2. White vignette (subject fades into white background) is produced by giving normal exposure to subject and no exposure to surrounding area. To do this, cut a hole the shape of subject (and a little smaller) in a piece of cardboard. Then, when making the print, hold the cardboard about six inches above the easel and project image through hole onto paper. For soft-edged vignette, make serrated hole in cardboard, and keep cardboard moving in gentle circles during exposure.

3, 4. Black vignette is produced by giving entire sheet of paper normal exposure, then burning surrounding area black by giving it 30 seconds of exposure with lens wide open while covering subject with cardboard cutout.

4

The Sabattier effect, sometimes known as solarization, is produced by exposing partially developed print to light, then putting it into fixer before it turns all black. Expose a sheet of printing paper a bit less than is required to make a normal print from negative you are using. Develop the print for a full 2½ minutes, then expose it briefly to white light. This exposure is most easily controlled if enlarger (with no negative) is used as light source, but any white light source will do. Watch print under safe-light. When desired effect is obtained, transfer print to fixer.

Just how much exposure to white light you should give the print while it is in the developer is something you'll have to determine by experimentation. Tips: Contrasty paper works best, as does old, weak and/or diluted paper developer.

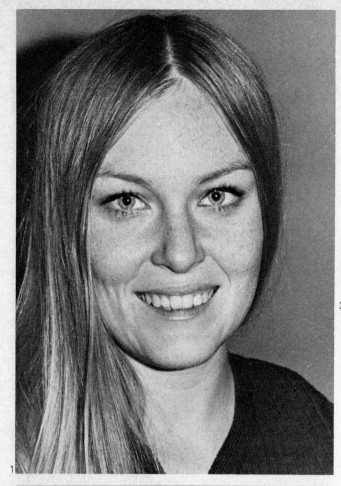

1

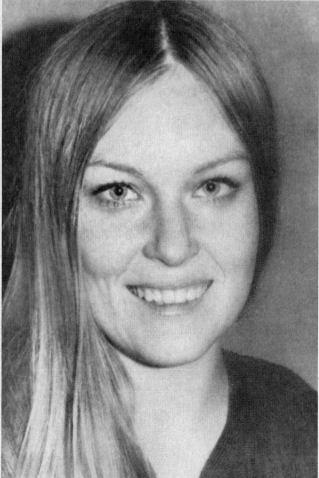

2

3

1, 2. You can use the paper itself as a diffusion material while printing. Turn negative emulsion-side up in the negative carrier, and put the paper in the easel upside down. Since you're printing through the paper's backing, you'll have to use more exposure than for a normal print—try about eight times the normal exposure (open lens three stops). Tip: Use single-weight paper. 3. You can eliminate all gray tones from a print by using litho film and high-contrast paper. Kodak, Ilford, Nacco, Agfa and Du Pont make litho films, which are very high-contrast films. Agfa grade No. 6 paper is excellent. Procedure: Put a sheet of litho film in easel, and a normal negative in enlarger. Make exposure and develop litho film as per manufacturer's directions. This will give you high-contrast positive of your negative. Dry litho positive, then contact print it it on another sheet of litho film. Dry this, and you will have high-contrast litho negative to contact print onto high-contrast paper to obtain print like this one. For information on variation possibilities, see Petersen's Guide to Creative Darkroom Techniques.

negative stage (if possible) so that imaginary lines drawn through the lens plane, the negative plane and the paper (easel) plane all intersect at one common point (see illustration). This will result in the greatest depth of field. You might be able to prop up one side of the negative carrier with a coin or coins, if your enlarger does not have provision to tilt the lens or negative stage.

If no tilting of the enlarger components is possible, it is best to focus on a point on the easel about one-third of the way from the highest edge, and then stop the lens all the way down and hope. □